The Feminine Voice
of Islam

The Feminine Voice of Islam

Muslim Women in America

NAJWA RAOUDA

South Bend, Indiana

The Feminine Voice of Islam: Muslim Women in America
Najwa Raouda

Copyright© 2008 by Najwa Raouda
ALL RIGHTS RESERVED

Published by
The Victoria Press
An Imprint of Lirio Corporation
South Bend, Indiana 46601

www.TheVictoriaPress.com

Library of Congress Cataloging-in-Publication Data

Raouda, Najwa, 1949-
 The feminine voice of Islam : Muslim women in America / Najwa Raouda.
 p. cm.
 Includes bibliographical references and index.
 Summary: "Muslim women who immigrate to the United States from various Islamic countries encounter conflicts between their own cultural traditions and a pro-feminist American society. This study examines their experiences and may lead to the formation of a curriculum which helps to smooth the process of cultural integration" --Provided by publisher.
 ISBN-13: 978-1-929569-51-9 (pbk.)
 ISBN-10: 1-929569-51-3 (pbk.)
 1. Muslim women--United States. 2. Muslim women--United States--Social conditions. 3. Feminism--United States. I. Title.

HQ1170.R39 2008
305.48'6970973--dc22

2008017228

Printed in the United States
on recycled paper

Contents

1. Introduction 7
 Muslims in America: An Overview 7
 Religion in Culture: The Study 9
 Problem Statement 11
 Research Question 13
 Epistemology 15
 Methodology: Research and Interpretive Lens 15
 Theoretical Perspective 16
 Thesis Statement 17
 Statement of Purpose 18
 Significance of the Study 19
 Limitations of Study 20
 Organization and Structure of the Study 21

2. Review of the Literature 23
 Muslim/Arab Immigrants: Becoming
 and Being Americans 24
 Theories and Symbols of Integration 25
 Pressure & Stress with Immigrants 26
 Keeping and Breaking Away from Traditions 28
 Feminism in Islam 30
 Feminist Voices within Islam 33
 Making Their Presence Visible: The Veil in Islam 35
 The Veil as an Identity 36
 The Veil: A Symbol of Resistance to Modernism 37
 Motivated by Feminist and Critical Lenses 39
 Conclusion 42

3. Methodology And Procedures 43
 Approaching the Study Qualitatively 44
 Theoretical Perspective 45
 Why van Manen's Approach? 47
 Research Context 48

 Sampling Strategies & the Participants 48
 The Procedure/Process 50
 The Interviews/Data Collection 51
 Data Analysis 54
 Judging the Rigor of the Study 55
 Conclusion 60

4. Findings 61
 What They Said & What I Learned 61
 Descriptions of the Study Participants 62
 Demographic and Individual Descriptions
 of Participants 63
 Document Analysis: Emergent Themes 80
 Conclusion 100

5. Conclusions & Implications 103
 Discussion 103
 The Findings Suggest 104
 Implications: A Curriculum 117
 Limitations & Future Research 126
 Final Thoughts 127

References 129

Index 137

1. Introduction

Muslims in America: An Overview

Millions of Americans are Muslims/Arabs. Some are first generation immigrants to the U.S. who considered America a land of opportunity and freedom, while others were born in the U.S. as second or third generation of immigrants. Afridi (2004) stated that "between five to eight million Muslims make America their home, making the U.S. the most ethnically diverse community of Muslims anywhere" (p. 2). Getting a reliable count on Muslims in the U.S. is difficult because of federal laws, but Mairson (2005) identified 1,209 mosques that suggest a population of six to seven million Muslims in the U.S. (p. 2). While Arab Americans come from 22 different Arab countries, the Muslim-American population is comprised of people from the entire world. Still, the public knows little about how Muslim immigrants live, how they think, what objectives they seek, how they retain their cultures and religion, how they regard their obligations toward family and society, how they establish an identity in the United States, what educational needs they face, and how they consider women's rights: realities that usually marginalize Muslims/Arabs and isolate them in their Islamic rather than involve them in the mainstream of the nation.

Islam includes more than a billion people in the world and

is the fastest growing faith in this country. Haddad and Lummis (1987) described how the faith is an "American phenomenon. Once thought of primarily as the way of life of the Arabs and a faith alien to the ... heritage in this country, it has moved into a position of sufficient size and strength that it must be courted today as one of the prominent, and rapidly growing, religious movements in America" (p. 3). The reasons behind the growth of Muslims in the U.S. are the high rate of birth, the growing numbers of converts, and the continuous flood of Muslim immigrants from all continents. A demographic survey by Zaman (1981) produced an estimate that "by the first decade of the twenty-first century Islam will be the second largest religious community in the United States (after Christianity)" (Lummis, 1987, p. 3).

More than 80 percent of Arab/Muslim Americans are U.S. citizens with a heritage that reflects a culture thousands of years old. However, in the process of becoming and of being Americans, Muslims/Arabs have to deal with what language to teach their children, how to help maintain their faith in a new environment, how to secure their traditions, and how to best prepare their children to be successful and accepted in pluralistic America. Haddad (2002) described how Arabs and Muslim Americans "see their marginalized reality in the U.S. as deliberate and specific [and] ... at times experienced a manifestation of Western 'anti-Arab' or 'anti-Muslim' sentiment" (p. 110). The World Trade Center catastrophe brought Islam, Arabs, and Muslim Americans into a critical light causing many Americans to view Muslims with fear and distrust. The faith and its followers became a matter of public discourse in America, and many Americans found themselves knowing little about millions of Muslims who live in their communities and nation. The media reflected an increased attention on Muslims ranging from Afghanis, to Iraqis, to Iranians, to Saudis, all with connections to wars and tragedies. To many Muslim/Arab Americans, 9-11 in 2001 represented a turning point in how America accepts

Muslims/Arabs in the community with their distinct religious identity.

It was at that time that I was considering a subject for a book and my advisor suggested that I, being an Arab immigrant, introduce the conditions and the challenges of Muslim/Arab women in the United States. I conducted a pilot study on Muslim/Arab women's literacy in the U.S., and I became interested in pursuing the subject deeper. I chose to study Muslim/Arab immigrant women and their challenges of integration, living in a new environment, becoming Americans, keeping or losing their traditions, and varying their views of feminism with a concern for their educational needs.

Thus, the purpose of the research was to study the Muslim/Arab women's oral histories and their lived experiences which helped value others' voices and shared new and different aspects of reality and knowledge. I based my work on Freire's (1991) Pedagogy of the Oppressed, and Pedagogy of Hope (1994) in aiming to understand those Muslim/Arab women's attitude toward feminism as they came in touch with new aspects in a new environment.

Religion in Culture: The Study

The study on Muslim/Arab women in America presents the challenges of some Muslim/Arab women whose experiences in a new environment, the United States, have molded their perspectives, changed their conceptions of belonging, and motivated their aspiration for advancement. This research aimed to study those women's voices and understand their concerns in their pursuit to improve themselves and their families' social, professional, and educational status.

The project was significant to education because it explored the different levels of acculturation, coping mechanisms, gender role ideologies, affiliations to religion, adjustments to conditions where the women lived, and the social/familial behaviors of a sample of Muslim women in America. The project presented

how the participants tried to find new ways of knowing about living in a new environment and how they were motivated to better their families' educational and social levels. Studying how the culture might/might not hinder the women's individuality raises interesting subjects for educators who might benefit from understanding these women's experiences. Understanding Islam, the veil, awareness, levels of integration, traditions, and the feminist voices in Islam can be enlightening, and this knowledge may touch educators in understanding mothers of Muslim children in their schools.

Most importantly, the project was significant from a social justice point of view. Helping the participants come to a new, deeper meaning in their lives was important for liberating them from social hegemonies and setting them freer in their new environment. Reflecting on women's voices from the stance of feminist discourse is potentially enlightening, educating, and just. Freire's cornerstone theory and practice (1970) presented the idea of power, dialogue, and "conscientizacao" – "learning to perceive social, political, and economic contradictions and to take action against the oppressive elements of reality" (p. 19). Freire acknowledged that society can give voice to the knowledge of oppressed peoples only by providing structures that allow them to speak for themselves. In the case of this study, it is deriving knowledge from the women's stories and getting to a deeper identification with their struggles in a foreign environment. One aim of this project was to clarify some of the misunderstanding and ignorance that has developed between women in the European and American world and women in the Arab world, which can be traced to assumptions that the symbols and content of women's oppression are constant across cultures; that how women look and act have a similar meaning everywhere; that the issue of women's liberation as it has developed historically in the West should prove to be the same in the Arab world (Tucker, 1993, p. viii). The project helped to clarify such misconceptions and misunderstanding and presented possible genuine answers

to issues of concern to Muslim women, not issues that are presumed to be so.

Problem Statement

Muslim/Arab women in the United States have commonalities and differences in their ways of life and their beliefs and perceptions that mold their lives. What it is that we do not know about Muslim/Arab women is their daily struggles with a traditional culture which is a significant component of their lives, their challenges in a new and very different culture, and their voices that are sometimes silenced and at other times pleading to be heard. We also do not know how these women give meaning to their daily social and religious being, how they adapt to new demands, and how they shelter themselves, or are sheltered by their husbands and friends (for fear of becoming a part of the new culture), how they are selective in what to follow and what to reject in the United States, and how strongly attached they are to their traditions and language as a means of strengthening themselves and their families from becoming totally, and "dangerously" submerged in America's melting pot. Furthermore, we do not know how Muslim/Arab women deal with daily life necessities including shopping, driving the children to schools, school parent conferences, helping with their husbands' business and personal demands, socializing with other Muslim/Arab women in the mosque and at home, scheduling doctors' appointments, studying whatever they believe is of importance in their lives, bridging the gap between the two cultures, and trying to keep their children become attuned to their mother language and culture. Schools at various levels need to understand this group as education aims at democratic inclusion of Muslim/Arabs. McLaren and da Silva (1993) stated that "without a shared vision of democratic community we risk endorsing struggles in which the politics of difference collapses into new forms of separation" (p. 71). In multicultural education, including voices of Muslim/Arab women and

critically understanding their culture and gender increases our knowledge base.

By sharing their experiences, the participants might have had the opportunity to rethink their own meanings. My hope was that through discussion, interviews, and observations, the participants might find new perspectives in their lives; might develop a critical attitude toward society, history, culture, etc.; might draw independent conclusions and plans of response; and might go beyond traditions and culture to realize aspects of traditions deemed to be oppressive. I quote Al-Taimuriya, a feminist Muslim poetess from the late nineteenth century, whose lines shows anger, challenge, and hope with her situation as a Muslim woman in her verses from "Embroidered Ornaments" (1965, pp. 45, 59, 93).

> I challenge my destiny, my time
> I challenge the human eye
>
> I will sneer at ridiculous rules and people
> That is the end of it; I will fill my eyes with pure
> Light, and swim in a sea of unbound feeling.
>
> I have challenged tradition and my absurd position,
> And I have gone beyond what age and place allow.

This project described the process through which the participants did or did not encounter conflict between tradition and critical feminism. Their experiences in the American environment, given that they came from a more traditional environment, might shed light on what those women wished to adapt to or escape from. The purpose was to elaborate on the women's daily experiences and to try to find multiple levels of meaning, knowing the complexity of their lives.

Research Question

In conducting this study of Muslim/Arab women in America, a central question was asked: "How did Muslim/Arab women from different parts of the Middle East encounter conflicts between traditionalism and feminism in the United States?" Traditionalism, feminism, tradition, and Muslim-Arab women as concepts and as used in the study are defined below:

The concept of feminism, as described by Routledge Encyclopedia of Philosophy (1998), is one that is "grounded on the belief that women are oppressed or disadvantaged by comparison with men, and that their oppression is in some way illegitimate or unjustified" (p. 576). My study presented issues that related to women's understanding and evaluating knowledge from their points of view, looking at the world from a female perception and departing from the usual male concept of knowledge. Feminism demands that women have the choice of and accessibility to education, work, and civil rights, regardless of cultural or religious constraints. There are multiple kinds of feminism ranging from liberal, to radical, to Marxist and Socialist, to cultural, to eco-feminism. However, in this study I chose to seek the different voices of feminism in Islam.

"Traditionalism," as described by Routledge Encyclopedia of Philosophy (1998), refers to "a consistency of practice, believing, and ways of doing and being – cultural and/or social – over a long period of time, often centuries, among a specific group of people. Traditionalism is the attitude which prioritizes tradition over less dated ways of doing or being" (p. 575). It is the preference over more recent practices, views, ideas, etc., otherwise called "contemporary" or "modern." In this study, traditionalism referred to the twentieth-century anti-modern movement that was led by the French philosopher Guenon who regarded modernity as dark, and who opposed not the West but the modern world. Guenon hoped for the restoration of the West to an appropriate traditional civilization: The Eastern Islamic one (Sedgwick, 2004). Traditionalism aimed at restoring "traditional

civilization to the West" affected mainstream and radical politics in Europe and the development of the field of religious studies in the United States. In this study on Muslim immigrant women, I used the concept of traditionalism to reflect on the debate in the Islamic world about the relationship between Islam and modernity with issues of gender roles, keeping the traditions of the faith, making women's presence visible by wearing the veil and the hijab, and having a voice within Islam.

Tradition: Routledge Encyclopedia describes "tradition" as a "body of practice and belief which is socially transmitted and is accorded greater authority in the present because it … encapsulates the wisdom and experience of the past" (1998, p.445). In this study, traditions referred to the social and religious practices that Muslim women abide by and believe to be commandments from God which include the cultural practices and rituals of Islam such as the Five Pillars that are the foundation of Muslim life: Faith in the Oneness of God and the prophethood of Muhammad, daily prayers, almsgiving, self-purification by fasting, and the pilgrimage to Mecca for those who are able.

The term, "Muslim/Arab women," refers to recent women immigrants who are either Muslims or Arabs, and therefore, shared either Muslim religious tradition, Arab culture, or both.

Thus, from the participants' oral histories, I tried to know how Muslim/Arab women dealt with new conflicts between what they traditionally knew, and what they were acquiring and learning about feminism in their new homeland. I planned to find out how they had been challenged with new issues, what their hopes and fears were, what they wished to change in their lives then and in the future, how closely they kept to their traditions, how they regarded veiling, how they socialized, and how they dealt with issues of silencing, religion, education, health, feminism, and future aspirations.

Epistemology

In the domain of epistemology, I minimized the "distance" between me as researcher and those being studied (Guba & Lincoln, 1998, p. 76). In this project, I used constructivism as the form of epistemology in order to inform the theoretical perspective of my project. According to Crotty (1998) constructivism "claims that meanings are constructed by human beings as they engage with the world they are interpreting ... it is the view that all knowledge, and therefore all meaningful reality as such, is contingent upon human practices, being constructed in and out of interaction between human beings and their world, and developed and transmitted within an essentially social context" (Crotty 1998, pp. 42-43). The theoretical perspective in research is a way of looking at the world and making sense of it; it is a way that presents meaning that comes into existence in and out of our engagement with the realities in our world. It is important in my project to construct meanings from what the Muslim/Arab women told me. What made the project interesting was that since different people constructed their meanings differently from others, in a constructivist epistemology my subjects and I became "partners in the generation of meaning" (Crotty 1998, p. 9); we started deriving new meanings of concepts that the participants inherited, acquired, practiced, and in many cases believed in.

Methodology: Research and Interpretive Lens

The methodology I used was qualitative since the objective was to make meanings from the Muslim/Arab women's experiences in the United States. Being an Arab immigrant to the U.S. myself and sharing similar experiences with the Muslim/Arab participants, I decided to investigate the participants' stories. From the experiences of ten Muslim/Arab immigrant women, I wanted to derive meanings that could lead to a later curriculum that could include their voices and concerns. The participants in

the study were from different countries ranging from Jordan, to Iran, to Cyprus, and even to India. What was common among the participants was that they were all Muslims and they all experienced the authentic life of women in Islam. My strategy was to get deeper in the participants' experiences in order to provide to the readers rich descriptions of what they narrated.

Theoretical Perspective

I employed both feminism and critical inquiry as tools in my study that could compliment constructivism, the theoretical perspective I chose. Both tools were behind the methodology of my project as "the theoretical perspective provides a context for the process involved and a basis for its logic and its criteria" (Crotty 1989, p. 66). My aim in the qualitative research was to make sense, interpret, and understand the experiences of Muslim/ Arab women, how their culture molded them, how the new culture affected them, and how they resolved the conflict between traditionalism and feminism in the United States, from a feminist stance. I aimed at "gaining an understanding of the text that [was] deeper or [went] further than the author's meanings or understanding' (Crotty 1998, p. 91). Such an understanding was achieved through the voices of the women participants in a feminist theoretical perspective.

Within the feminist inquiry, I sought to understand how the Muslim/Arab women in my project understood their gender and how far they acknowledged that gender was a social construct that differed for each individual. We realize that feminists speak in myriad ways and bring about conflicting and differing points of views and assumptions to research. They speak in a voice that is different from what women are accustomed to hearing in a patriarchal world and in a Muslim culture that instills masculine rights over all rights. Moghadam (2004) defined Islamic feminism as "part of what has been variously called Islamic modernism, liberalism, and reformism" that refuted Western stereotypes and Islamic orthodoxy alike (p. 2).

Introduction

I chose to follow the feminist theory which tries to construct knowledge and understand reality from the perspective of women as presented by both Collins and Harding (1998) in their emphasis on feminist standpoint epistemology. Why did I choose a feminist inquiry for my project? Simply, because, I agreed with De Beauvoir (1953) that "one is not born, but rather becomes a woman" (p. 273).

Since my interviews focused on the Muslim participants' lived experiences in a new environment, I also based my work on the hermeneutic phenomenology of Max van Manen. His approach to education was consistent with my focus on women's reflections of their experience. Van Manen (1990) stated that:

The interpretive approach to understanding the nature of a social phenomenon involves the researcher in making explicit the meaning of a particular lived experience, and generating a pedagogical thoughtfulness in his or her readers. The aim of hermeneutic-phenomenology is to create a dialogical text which resonates with the experiences of readers, while, at the same time, evoking a critical reflexivity about their own pedagogical actions. (p. 70)

Thesis Statement

The project, "Muslim/Arab Women in America" presented meanings and oral histories of Muslim women who agreed to participate in sharing their stories and in trying to derive meanings of their experiences in the United States. My primary focus was how Muslim/Arab women dealt with their conflicts between their traditional practices and what they learned in the new homeland. The work emerges from a pilot study that I conducted two years ago about Muslim women and literacy in the United States. The pilot study included participants from Turkey, Lebanon, Syria, and Iraq and resulted in rich data that reflected the women's experiences as they were lived and felt. Two out of four women gave me the chance to work individually with them to improve their English language and their understanding

of American culture.

Lastly, from the women's biographies and interviews, I hoped to faithfully, present and, respectfully, appreciate all views on different themes. I realized that feminist research is always a struggling to reduce, if not to eliminate, social injustices and hegemonies inherited from culture or imposed by men. Rich (1990) believed that "all human life and every human situation can be seen as a text. As they address that life and those situations, inevitably sexist as those understanding are, and interpret life and situation anew- yes, reading them as they have never been read before" (p. 484)

Statement of Purpose

Educators may need to know what they can do in the future to make it easier for women who migrate from Arab or Muslim countries to become integrated into American society. Integration is educational, formal or informal. The questions on educational implications are answered by new curriculum.

In a multicultural society, education empowers individuals and promises success, recognition, and smoother integration. Since there are five to eight million Muslims residing in the U.S., devising a curriculum in the future for new women immigrants, which can be taught in community centers, schools, or in mosques, is a way to ease their integration and inclusion. In addition, history about the Arabs and Muslims is not taught in American schools; including voices of Muslims/Arabs in education is democratic. Best (1989) affirmed that "without a shared vision of democratic community, we risk endorsing struggles in which the politics of difference collapse into new forms of separatism" (p. 361). My study was an introduction to new realities and knowledge from Arabic and Islamic backgrounds.

Learning and educating about the lives of Muslim/Arab women in the United States brings educators closer to true multicultural education and to the challenge of diversity. Schools are preparing and training teachers to work effectively

with culturally diverse student populations because of the demographics changes in the cultural composition of American schools: Muslim/Arab students are a considerable portion of the educational system. Van Manen (1990) emphasized how "educators have a professional interest in biographies because from descriptions of lives of individuals they are able to learn about the nature of educational experiences and individual developments" (p. 72). In addition, knowing more about Muslim/Arab women in the U.S. can pave the way to educators who can "gain insights into the lives of particular students in order to understand more sensitively from where they come from and to where [they] can go (van Manen, 1990, p.71-72).

Significance of the Study

I found few studies on immigrant Muslim/Arab women and their acculturation. The information that I gathered in this study was of significance to the body of knowledge on Muslim immigrant women in more than one aspect. First, it broke new ground within the field of education, as there were no studies that utilized Muslim women's experiences and practices in the United States and made meaning of their knowledge to be further used in curriculum. The answers brought to light what Muslim women did, struggled with, thought, and believed as they tried to survive a culture that was totally different from theirs. Second, the study helped to break down stereotypes about Muslim women and about Islam at a time when the world was seeking to find answers about who Muslims were, what they believed, and what their life-styles were. The media have often projected negative images of Muslim women, and none of my participants matched any negative image projected and presented by the media. Third, the study brought some insight into how Muslim women regarded family and extended family, marriage, solidarity in mosques, feminism, and other issues that are debatable and that we learned about from different points of view. The study showed how immigrant women selected what to

conform to from the host country, and what to keep from their cultures. Muslims in America started acquiring new concepts even as they tried to keep to their rituals and traditions that secured their identity.

Most important, the project was significant from a social justice point of view. I believe that educators might benefit from understanding those women's experiences as they reflected the culture, the countries, the geography, and the social and political issues of each participant's background. I considered it important for educators to know about the roles of Muslim mothers, their perceptions, acts, and how they affected their children's school experiences. Such knowledge can help reduce marginalization of Muslim children in schools. Increasing social and self awareness for participants through feminist discourse was a way of empowerment that could help decrease marginalization through illuminating the demythifying culture, and providing venue for voices to be heard. The study recommends developing a curriculum, from women's voices, that would be tailored to meet the needs of new immigrant Muslim women to the United States. I believed that a new curriculum can provide a smoother socio-educational integration for Muslim women and their needs in America. No other apparent studies point to a concrete educational curriculum that could be taught in educational centers, in mosques, or in colleges.

Limitations of Study

Being an Arab, a feminist, and one who lived the Islamic culture, it was hard for me to be objective. I had to remind myself that I was conducting research that required my objective findings without being biased. I was aware that my own personal values and preferences (beliefs) could potentially influence my investigation. This was something I was aware of and I have taken every possible and appropriate measure to prevent such biases from influencing the finding and conclusions. After interviewing ten participants, I found that I collected overwhelming, but

interesting, data. However, due to limitations of space, time, and need, I did not present all the themes that I found but focused on a few for the present project. Another limitation was that all the participants lived in a certain area in the United States, and their experiences might have been similar to other Muslim women in other states, but I could not prove it in my present project. One major limitation was the inability to include more Muslim participants from almost every country and social class assuming that the origin and the status of the participants usually play major roles in their integration in any new environment. One last limitation was that three of the participants from Cyprus, Syria, and Turkey were personal friends who agreed to participate in the study. Although prior knowledge of the participants may not be a limitation, the fact was that I knew more about them than what I collected from interviewing them.

Organization and Structure of the Study

This study is divided into five chapters:

> Chapter One includes reasons for the significance of the project to education and to myself, thesis statement, projected results, and a road map.

> Chapter Two presents the literature review that I read and cited in order to place my topic in the context of prior research. The chapter is organized around two themes: Immigration/integration in the United States and feminism in Islam.

> Chapter Three details the methodology and the methods that I followed. It also includes the population, sampling, procedure, methods of

data collecting, and methods of analysis.

Chapter Four presents results from the interviews conducted: what the participants said and what I learned.

Chapter Five further discusses the implications and what can be done with the study in the future.

2. Review of the Literature

I have chosen to approach the literature review from what I consider to be major themes that relate to this study of Muslim/Arab women in the United States. This study reveals how the Muslim/Arab participants faced acculturation and how their level of adaptation and integration depended on many variables. As immigrant women, the participants developed new concepts of feminism in the United States, and the literature I reviewed reflected on how far the participants modified or preserved what Islamic feminism was to them. The study tried to look for the participants' past in Arabia or in Muslim countries, their experiences in America, and proposes how we can use past and present to structure education of either assimilation or integration so that other women, who will come to the U.S. will have an easier assimilation and integration. I placed my study in the context of prior research and looked for theories and articles that dealt with the themes from different angles. Divided into two parts, this review of literature begins with the theme of immigration and how it affects Muslim women. The theme covers Muslim/Arab women becoming Americans, the theories of integration, the pressures they feel, and the traditions they maintain. The second part looks at feminism in Islam. This theme covers feminist voices in Islam, feminist voices within Islam, and what the traditional veiling and hijab stand for.

Muslim/Arab Immigrants: Becoming and Being Americans

Muslim/Arab immigrants have been engaged in the process of being and becoming Americans for the last century (Haddad, 2000, p.109). The process has not been easy, as researchers have found. Immigrants brought their distinctive identities, beliefs, ideologies and practices that have affected their own generation in their countries as well as their new generations in the host country. The process of being and becoming Americans has been affected by the national origin of the immigrant, by their ethnicities within each nation, language, dialect, political affiliation, place of residency, waves of immigration, culture, levels of acculturation/ integration, and gender.

Grieco and Boyd (1998) in "Women and Migration: Incorporating Gender into International Migration Theory" argued that migration research remained insensitive to gender. Their study incorporated women's issues into migration theory and developed a multi-level theoretical framework more appropriate to study the experiences of the migration of women and men. The authors described the gender and the pre-migration stage divided into areas of gender relations, status and roles, and structural characteristics of the country of origin (p. 111). The Muslim/Arab participants' adaptation to a new culture and their levels of integration depended much on their gender, status, education, and country of origin.

Digh's (2003) "The White Leg Syndrome" described acculturation as the "process of intense socialization that brings about an individual's integration into or adoption of another culture, especially that of a foreign country." The article suggested that in order to understand about workplace cultures everyone must understand the definition of key terms related to culture: terms like acculturation, assimilation, melting pot, salad bowl, dominant culture, and inclusion. However, Digh (2003) quoted that in a recent poll by the Program on International

Policy Attitudes at the University of Maryland, 91 percent of U.S. citizens agreed that the "global economy makes it more important than ever for all of us to understand people who are different than ourselves" (p. 69). More importantly, we must first understand ourselves and see our own cultural norms more clearly to avoid "dominant culture think". The article suggested that "success in the next decades depends on the alliance across cultures, products, and service lines" (p. 69) which encouraged inclusion to all cultures and finding ways to make it easier for others to integrate more smoothly.

Theories and Symbols of Integration

In order to understand how immigration affects all immigrants, including the Muslim women in this study, we need to understand the theories of integration in the United States. Immigrants to the United States are left with three possible theories, or metaphors, for their integration: the melting pot, the salad bowl, and the ethnic stew. The melting pot was a model that earlier immigrants, who saw benefits in 'melting' their characters, language, and ethnic rites in the ruling culture. The salad bowl model keeps the ingredients visible among the diverse groups. Glenn (2004) questioned the old models of assimilation and presented how social scientists are "cooking up a new melting pot" (A10). Glenn believed that "today scholars have the opportunity (and, often, the language skills) to concentrate on less-assimilated first-generation migrants [as they entertain] models of robust pluralism and transnationalism" (A10). However, ethnic stew (where immigrant identities develop relationships with the larger society while keeping their ethnicity,) is the most approached with Arab/Muslim immigrants. In many cases, immigrants nowadays "do not feel it necessary to give up their culture of origin in order to adapt to the new society" (Phinney, Horenczyk, Liebkind, & Vedder, 2001, p. 495). The majority of the Muslim/Arab participants in the study embraced their ethnic identity since it included "self-identification, feelings of belongingness and

commitment to a group, a sense of shared values, and attitudes toward one's own ethnic group" (Phinney et al., 2001, p.496). Hence the participants, from diverse Islamic countries, focused on the subjective sense of belonging to an Islamic culture and the hope to be able to live in an expanded public space where all can contribute in the modern society while keeping their distinctive ethnic identity.

Pressure & Stress with Immigrants

Life in an unfamiliar culture presents situations that usually cause stress to the immigrants because of their insufficient understanding of the symbols and activities of the new environment. Parrillo (1966) described how "to strangers, every situation is new and is therefore experienced as a crisis" (p. 3). Immigrants find themselves in a new and unfamiliar environment where many have to start an "enculturation (the ability to organize one's activities with the activities of others in the society) process all over again" (Kim 2001, p.48). Many of the Muslim/Arab participants in the study experienced stress and pressure according to their levels of understanding the English language and knowing the laws of the new environment.

Phinney et al. (2001) reviewed "current theory and research regarding ethnic identity and immigration and the implications for the adaptation of immigrants." (p. 493). The study suggested that "where there is pressure to assimilate and immigrants are willing to adapt to the new culture, national identity should be predictive of positive outcomes. When there is a strong supportive ethnic community, ethnic identity should predict positive outcomes" (p. 494). The Islamic ethnic identity prevailed with the participants because they had a strong Islamic supportive community, especially in the mosque where women shared their experiences to ease one another's cross-cultural adaptation and kept a system of cultural retention: circles in the mosque and other social networks. Thus, adaptive change inevitably causes stress in the stranger's psyche-a conflict between the desire to

retain old customs and keep the original identity ... and the desire to adopt new ways to seek harmony with the new milieu (Boekestijin, 1988; Zaharna, 1989). Kim (2001) defined stress as "the manifestation of the generic process that occurs whenever the capabilities of the individual are not adequate to the demands of the environment" (p. 55).

Abuzahra's (2004) "Understanding Resilience in Muslim-American Immigrant Women: An Examination of Protective Processes" was a study of nine resilient Muslim immigrant women who faced risks and challenges that are common with other immigrants, like language, but they also had to face other challenges of dealing with stereotyping, bias and discrimination, especially post September 11, 2001. The study emphasized the importance of spiritual, familial, gender, and individual protective processes, and how faith has been at the core of easing their stress in a foreign environment. Abuzahra concludes that the process of immigration and acculturation has created unique stressors for all immigrants, and that true Islamic belief and extended family and community support played a larger role in life and decision-making for Muslim women (pp. 6-8).

Rida & Milton's (2001) "The Non-joiners: Why Migrant Muslim Women Aren't Accessing English Language Classes" discussed the disadvantages faced by migrant women from diverse cultural and linguistic background who experience a lower standard of English proficiency. The study reported that migrant Muslim women, due to their religious and cultural belief system, had needs and status different from those of other migrant women (p. 35). The study focused on the internal and external factors that influenced twenty-three Muslim participants to access or not to access their language entitlements. Factors like women's network and support, their desire to learn English, their willingness to participate in classes, their ages, number of children, and educational background, all were factors that affected how well Muslim immigrant women were ready to participate in ESL classes. The study ended with recommendation

of how to encourage "Muslim immigrant women to access their language entitlements and how policy makers have to better understanding of the cultural and religious issues which exert such a great influence on the daily lives on Muslim women" (p. 47). Although the study was conducted in Australia, still the findings and the factors that affected the immigrant Muslim women were similar because they were rooted in the same culture and religion.

Keeping and Breaking Away from Traditions

For their easier assimilation and success in a foreign environment, newcomers seek a certain level of transformation that allows both keeping what they like of their traditions and breaking away from what may be culturally restricting. Since cultural assimilation goes hand in hand with education, class, and economic advancement, Kay (2004) suggested that the poorer the immigrants were, the more difficult it would be for them to break away from "their ethnic enclaves and integrate into American society [so that]... eventually they may form a permanent, half-assimilated ethnic, underclass" (p. 67). This researcher asserted the best way to avoid such a fate was for the government to emphasize job skills, education, and English-language proficiency (Kay, 2004, p. 67). Such recommendations proved to be ideal in creating smoother integration for immigrants that do not require immigrants to totally assimilate in the new environment, but to keep their ethnic identity while participating in a modern society. Gauger's (2003) "Immigrant Muslim Women Working in America" presented how many Muslim immigrant women in America are breaking away from traditional interpretations of the Quran and are joining the workforce. Gauger cited the many laws that protect employees from ethnic and racial discrimination that new immigrants need to know about for their smoother integration.

Giorgio-Poole's (2002)'s study "The Religious Lives and Ritual Practices of Arab Muslim Women in the United States: A Comparative Study" was a study that investigated the religious

lives and ritual practices of twenty-nine middle-class Arab Muslim women from two states in the U.S. "The central focus is the influence of the dominant non-Muslim culture on their involvement in home-based and mosque-related formal and informal religious observances." (p. iii). The study concluded how the Muslim women participants, despite the difficulties in a foreign environment, "were content with the material benefits and religious freedoms they enjoy in America" (p. iv). The study was relevant to my research, but it focused only on women from the mosque and their religious practices, while my study was more diverse as the participants were colorfully different.

Curran and Saguy's (2001) "Migration and Cultural Change: A Role for Gender and Social Networks" described the three important developments in the field of migration. the recognition that there are significant differences between men and women in terms of motivations, risks, and norms governing and promoting their movement and assimilation; the incorporation of social network; and the recognition that migration decisions are not made by atomistic individuals but conditioned by membership within households and communities (p. 54-55). The paper viewed culture to be "an essential component for understanding the meaning given to individuals (gender), their actions (migration), and their relationships (network ties) which influence the way inequality is produced or redressed" (p. 55). Thus, the study emphasized how networks that can bring social change can be improved to better help immigrant women and can ease breaking away from restricting traditions.

Kramsch's (2002) "In search of the Intercultural" reviewed Kim's (2001) theory of adaptation that explores key factors affecting the process: "such as, ... cognitive complexity, affective flexibility, motivation, aesthetic orientation, as well as technical skills, synchrony and resourcefulness ... preparedness for change ethnic proximity, and adaptive personality, as well as functional fitness and psychological health." (pp. 278-79). Kramsch chose one of Kim's (2001) most effective arguments about adaptation

with immigrants to the United States as they "become no longer cultural outsiders, but are able to activate a third culture perspective and become intercultural persons" (p. 278). Change is inevitable in immigrants' lives, and in my study change was most evident in the participants' views of feminism.

Feminism in Islam

Of the many forms of feminism, I chose feminism in Islam for my study. The current interest in the discourses of feminism, human rights, and democracy have encouraged and supported many Muslim intellectuals to explore feminist models of emancipation. Since feminism in the West is largely shaped by gender relations, economy, radical change in objectives and lifestyles, and by capitalism, Muslim feminists focused on presenting a genre of feminism that does not threaten the social ideology of the faith. If feminism is seeking a voice for women, it would be better to know whose voice we seek to listen to when we search for feminism with third world women, Arab/Muslim women in particular. As Muslim women seek freedom in Muslim spaces, they are usually sensitive to their roles in the communities as they realize that the goals of feminism, as conceived by Western society, are not necessarily relevant or applicable to Muslim women whose feminism is directly linked to religion and culture.

Faruqi (1999) affirmed that "if feminism is to succeed in an Islamic environment, it must be an indigenous form of feminism, rather than one conceived and nurtured in an alien environment with different problems and different solutions and goals" (p. 4). Feminism is not a novelty to Arabs/Muslims, but it is very different from the concept of feminism in the West. Lazreg (1988) invited readers on Muslim women or on women in the third world:

> to take intersubjectivity into consideration when studying [Muslim] women ... it means

seeing their lives as meaningful, coherent, and understandable instead of being infused "by us" with doom and sorrow. It means that their lives like "ours" are structured by economic, political, and cultural factors. It means that these women, like "us," are engaged in the process of adjusting often shaping, at times resisting and even transforming their environment. It means that they have their own individuality; they are "for themselves" instead of being "for us." An appropriation of their singular individuality to fit the generalizing categories of "our" analyses is an assault on their integrity and on their identity (p. 98).

Whether Muslim/women live in their culture or in a foreign one, like where my participants live, their conflicts are to be addressed within the boundaries and understandings of their culture and religion, and do not need to be compared or expected to achieve similar objectives as Western feminists. Hijab (1991) describes how Muslim/Arab "women's influence in society is primarily expressed through traditional structures, such as family ties where women's power and status increase with age and the number of children they bear, and through women's organizations [political, national, and social]" (p. 51)

Mojab's (2001) "The Politics of Theorizing 'Islamic Feminism': Implications for International Feminist Movements" showed how the "theoretical perspectives of identity politics, cultural relativism and postmodernism emphasize the uniqueness, particularism, and localism of each and every feminist movement" (p. 1). The study highlighted the differences between feminist women in the West and those in the East. Mojab presented how "feminist movement is global in the sense that women in almost every country of the world are engaged in various struggles to change their lives" (p. 1). However, Muslim women and Islamic feminists, like those in the feminist movement in Iran, have

advanced a new political approach to the state of women living in Islamic totalitarian states. Mojab detailed how since mid-1980, a new type of "Islamic women" has emerged creating "a new consciousness or a reformist trend", which some have called "Islamic feminism" (p. 3). The study is an ideal example of how consciousness in the Muslim world has emerged and how gender relations are changing, not necessarily like feminism in the West, but rather with boundaries set by religion and traditions.

Moghadam (2004) defined "Islamic feminism" as a "Koran-centered reform movement by Muslim women with the linguistic and theological knowledge to challenge patriarchal interpretations and offer alternative readings in pursuit of women's advancement and in refutation of Western stereotypes and Islamic Orthodoxy" (p. 1). Moghadam discussed Islamic feminism in a critical context of Muslim family, laws, and economy that aimed at marginalizing patriarchal forms of Islam and moving toward norms of justice, peace, and equality (p. 1). Moghadam's report clarified what Muslim feminists mean when they refer to feminism in Islam that is not separate from religion, but aims at reforming what has been misinterpreted in the religion.

Tohidi's (2002) "Islamic Feminism: Perils and Promises" described the unprecedented rise of literacy in women's rates in Muslim societies, noting that "the gender gap in the realm of education is closing and in some societies women's enrollment in higher education is equal to or even surpassing men's" (as is the case in the United Arab Emirates) (p. 13). This paper described an alternative view of modernity from the one Western feminists presented. Tohidi asserted "that women are not only affected by change but are themselves its agents", (p. 14) describing how Islamic Feminism provided a feminist reinterpretation of Islamic texts, an alternative view of modernity that called for the urgent development of tools for women (like knowledge of Arabic, the Quran and fiqh well as feminist theories and method) that enable them to redefine, reinterpret, and reform Islam to be a

women-friendly and gender egalitarian religion (p. 15).

Kamarck (2002) described how women met in Cambridge to draft a document called "Transition within Tradition: Restoring Women's Participation in Afghanistan" and sent an important message: "If you want to help us, let us do it our way," meaning the Islamic way. Rina Amiri, one of the leaders of the Afghan group points out that Muslim Afghani women "do not need to be 'liberated' from Islam" but they need to be armed "with the ability to fight Islam with Islam"(p. 2). Kamarck (2002) invited "Westerners, especially feminists to … [take] some pretty deep breaths … for the sake of Afghan women [to] try, this time, to do it their way" (p. 5). Such is the voice of many Muslim women who seek feminism that is in harmony with Islam.

Feminist Voices within Islam

Voices in feminism in Islam have been divided into dominant voices and alternative ones. In the first decade of the twentieth century, Muslim/Arab feminists in Egypt had already established dispensaries, nursery schools, charitable organizations for women and had become visible politically as they organized themselves and revolted against the British colonizers. However, as Ahmed (1992) detailed, over the first three decades of the century, feminism became visible intellectually, organizationally, and politically (p. 174).

The leader of the dominant voice was Huda Shaarawi (1879-1947) who was involved in the Egyptian national struggle and who organized a march of upper middle class women against the British in 1919. The alternative feminist voice led by Zienab Radwan, Hiba Ra'uf, and many other feminist scholars in Islam believed that Islamist women need to resist mainstream interpretations of Islam and the Shari'a (Ahmed, 1992) and find new interpretations from within the texts.

The dominant voice of feminism, which affiliated itself with the westernizing, secularizing tendencies of society (predominantly the tendencies of the upper, upper-middle, and

middle-middle classes) promoted a feminism that assumed the desirability of progress toward Western-type societies. Tohidi (2001) identified the trend of the "earlier pioneers of women's rights and feminism in the Middle East who were of a secular liberal, socialist ("Western") orientation [and] unwilling to breakaway from their religious orientation, and hold Islam as a significant component of their ethnic, cultural, or even national identity" (p. 13). The dominant voice of feminism a century ago trusted nationalism, secularism and equality in education, but the institutionalization of the nation-state as an outcome of secular epistemology has failed in the Muslim/Arab world and a new voice of feminism emerged.

The alternative voice opposed Western ways, and searched for a way to articulate female subjectivity and affirmation within a native Islamic discourse in terms of a general social, cultural, and religious renovation. Majid (2000) described how "the nation-state has had catastrophic effects on much of the Third World, where thousands of culturally autonomous communities were tyrannized by dictatorship and parasitic bureaucracies ... The rejection of certain Western secular models in the age of late capitalism is consequently a survival imperative for Muslim people, not just a fanatical reaction to 'progress'" (p. 119). What Muslims/Arabs fear is the removal of their epistemological, ethical, and religious values. Secularism, as the separation of state and religion, failed in the Arab Muslim world as it was imposed mostly by state and it "intensified the opaqueness of a Muslim subjectivity shrouded in a different 'regime of truth.'" (Majid, 2000, p. 3). Al-All's (1995) "Fundamentalism and Feminism in Egypt" reflected on the alternative voice of Muslim feminists led by Heba Ra'uf who advocated a new women's movement-an Islamic one: "Ra'uf is creating a new discourse on women and politics which is seen as liberal inside the Islamist movement" (p. 29). Ra'uf declared that she "believes in Islam as a world view, and [thinks] that women's liberation in our society should rely on Islam" (El-Gawhary, Interview, 1994, p. 27).

The Muslim/Arab participants in my research continue to have feelings of both acceptance and rejection to the aspirations of Western feminists. Harik and Marston (1996) illustrated how "while many [Muslim/Arab women] gladly seek out what the West has to offer, others prefer an identity distinct and separate from the West ... some welcome the freedoms and rights taken for granted by women in the West, while others strive to preserve the roles assigned them by traditional society" (p. 20). Whether the dominant voice or the alternative voice prevails on different issues of feminism, both categories of voices seem to agree that women are not so much fighting for the freedom to be women as for the freedom to be fully human with certain rights.

Making Their Presence Visible: The Veil in Islam

The veil and the hijab are at the core of Islamic traditions and religious beliefs. It is almost impossible to discuss issues about Islam, feminism, and traditions without presenting the debate about the veil or the hijab; both stand, visually and symbolically, as reminders of a conservative religion and of an identity. The contemporary fixation on the veil as the quintessential sign of Muslim resistance and cultural authenticity and the treatment of women epitomized Islamic inferiority (Ahmed, 1992, p. 14). The issue of the veil and the hijab has been debated in literature, history, and every society ranging from Islamic, to Arabic, to Western. The veil is to cover the face, while the hijab is to cover the body of a Muslim woman in public. Both words, veil and hijab, may be used as head-cover and are meant to promote privacy for females and to prohibit the intermingling of sexes. The veil and hijab are supposed to ensure modesty, decency, chastity and above all, respect and worship. The way the word veil is used in English is to conceal truth, or it can protect truth; in Arabic it is used in the sense of protecting purity. Thus, the veil becomes a symbol of purity that intends to send a message to the observer about the women in veil. Shakir (1997) cited a

Muslim woman, Khadija (a pseudonym) who comments on the veil, stating that "when you dress sexy, you feel sexy, and you go out and anything can happen to you. But when you're all covered up ... you're so pure and protected in your mind and in other people's minds" (p. 117).

Some believe that the hijab or veil is a tool of subordination invented by men to prevent women from public admiration and sexual availability. Ahmed (1992) described how the use of veil classified women according to "their sexual activity and signaled to men which women were under male protection and which were fair game... the division was fundamental to the patriarchal system and women took their place in the class hierarchy on the basis of their relationship (or absence of such) to the men who protected them and on the basis of their sexual activity" (p. 15).

Whether it is a hijab or a veil that makes a Muslim woman's presence visible, any or both reflect the woman's place in society and may hinder assimilation and integration in a new environment, at least visibly. A hijab or a veil tends to reflect on an Islamic identity and on a resistance to the modern world.

The Veil as an Identity

To many Muslim women, the veil is an identity; to others, it is a symbol of oppression, and to history it is a symbol of status. Mernissi's (1987) Beyond the Veil tries to familiarize the reader with the present-day Muslim world and demonstrate the importance of identity to individuals and to society:

> individuals die of physical sickness, but societies die of loss of identity ... a disturbance in the guiding system of representations of oneself as fitting into a universe that is specifically ordered so as to make life meaningful. Why do we need our lives to make sense? Because that's where power is (p. ix).

Mernissi (1987) demonstrates why fundamentalists in

Islam call for the return of the veil as a statement that "has to be looked at in the light of the painful but necessary and prodigious reshuffling of identity that Muslims are going through in their often confusing but always fascinating times" (p. ix).

Read & Bartkowki's (2000) "To Veil or not to Veil: A Case Study of Identity Negotiation among Muslim Women in Austin, Texas" examined the impact of veiling with a sample of twenty-four Muslim women: twelve of them veiled and twelve did not. The interviews with the participants "highlight how their gender identities reproduce and reformulate existing Muslim gender discourses ….with attention to the subjective disparities and points of congruence between both groups of respondents" (p. 395). Many of the participants stated that "veiling is a commandment in the Quran… it represents a submission to God… and is a symbol of worship" (p. 403). Many veiled in American because of their "feeling of connectedness with a broader religious community of other veiled Muslim women" (p. 403).

Majid (2002) affirmed that "whether veiled or not, women's conditions are determined not by the clothes they wear but by the degree to which they manage to forge an identity for themselves outside the discourses of modernity or religious authenticity" (p. 115). Islamic women have that power of using the veil and hijab as symbols of identity and of social and cultural reality.

The Veil: A Symbol of Resistance to Modernism

Afari (1998) examined the gender ideologies of several fundamentalist movements, gender relations, the battle over terminologies, and the political and economical explanation of veiling in the different Muslim countries. Afari drew on a study of 400 veiled and unveiled women at Cairo University conducted by Leila Ahmed, that showed "a direct correlation between the hijab and the economic level of the female students. Those with lower class parents are more likely to adopt the veil" (p. 89). Hence, the veil becomes a social conformity and not

a cultural identity. Afari (1998) argued that "since the Islamic movements are unwilling or incapable of carrying out a serious programme of redistributing wealth, they have instead attempted to construct the illusion of equality through the imposition of the veil" (p. 90). Finding values, identity, and uniqueness, and in a reaction against modernism, Muslim women's veiling becomes "a measure of women's alienation from modernization and its false promises... those women (who optioned to work) suffer from a gender division of labor which assigns them to low-status jobs, a class divisor which limits them to repetitive and boring work, and an economy that obligates them to work outside the home in a culture which sees women's primary role to be in the home" (MacLeod, 1992, p. 546).

Ahmed (1992) demonstrated that "the notion of returning to or holding on to an 'original' Islam and an 'authentic' indigenous culture is itself, a response to the discourses of colonialism and the colonial attempt to undermine Islam and Arab culture and replace them with Western practices and beliefs" (p. 234). The veil becomes a symbol of rejecting Western bourgeois capitalism that spread over the globe as a result of Western hegemony. Ahmed (1992) declared that "the reemerging veil attests, by virtue of its very power as a symbol of resistance, to the uncontested hegemonic diffusion of the discourses of the West in our age" (p. 235). By this concept, Islam questions modernity and what it stands for.

Kamarck (2002) described the veiled women in Afghanistan, like many women from the colonized world, seeking an Islamic path that could lead them to modernity since all other avenues were not successful: "for nearly one hundred years, periods of 'liberation' have been imposed on Afghan women by various 'modernizers' -- some home-grown, some, like the Soviets, imported. Without exception, the 'modernizers' failed and the backlash increased repression of women" (p. 2). Over hundreds of years of colonization, wars and increasing hatred of the West, emancipating women became a symbol of westernization and a

threat to Islam and its integrity.

Whether veiling stands as an Islamic resistance to modernism that seems as a threat to Islam or as a response to imperialism and nationalism, veiling has served to keep Muslim women's visibility covered. However, Minces (1980) stated that "modernization is not necessarily viewed in a positive light, particularly when understood as 'westernization'. Many [Muslim] women find the over-exposed style of western sexuality repulsive and they fear the breakdown in the extended family unit with the securities offered by such a social structure. Many women sincerely desire a more 'moral' economic, political and social life as prescribed by Islam." (p. 8)

Motivated by Feminist and Critical Lenses

"Muslim/Arab Women in America: A Study of Conflictual Encounters Between Traditionalism and Feminism" clearly reflects that I am interested in presenting issues of Muslim/Arab women who immigrated to the United States, on their conflicts between their traditions and their pride of traditionalism, and on their experiences from a feminist stance. To achieve such goals, I found it appropriate to employ both feminism and critical inquiry as tools for my research as I wished to observe, critically, through the eyes of feminist epistemology. With the Muslim/Arab women in the project, I wished to bring about "a feminist consciousness rooted in their concrete, practical, and everyday experiences of being, and being treated as women" (Stanely & Wise, 1983, p.18).

What motivated me the most was my interest in the feminist stance research that allows studying, analyzing, and explaining social phenomena from a gender-focused perspective. The approach emphasizes the fundamental importance of gender for understanding society and social relationships. The most prominent feature of feminist research "is the importance it places on gender in all phases of the research process from selection of a topic, through choice of design, to data collection

and analysis, and to interpretation of findings" (Thompson & Hickey, 2005, p. 47).

Harding (1991) described how "the distinctive features of women's situations in a gender-stratified society are being used by conventional researchers, that enable feminism to produce empirically more accurate descriptions and theoretically richer explanations than does conventional research" (p. 119). Harding (1991) further acknowledged that "for a position to count as a standpoint…, we should insist on an objective location –women's lives- as the place from which feminist standpoint research should begin … it is not the experiences or the speech that provides the grounds for feminist claims; it is rather the subsequently articulated observations of and theory that start out from, that look at the world from the perspective of women's lives" (p. 24). I looked for knowledge, not from what the Muslim/Arab women informed me from their daily experiences in the United States, but from what counted as true and meaningful from such valuable experiences and legitimate knowledge. Alcoff & Potter (1993) stated that "the history of feminist epistemology is the history of the clash between feminist commitments to the struggles of women to have their understandings of the world 'legitimated' and the commitment of traditional philosophy to various accounts of knowledge" (p. 2).

Such knowledge seeking requires democratic, participatory objectives where the researcher is aware of the depth of women's experiences and is aiming at producing knowledge from a feminist standpoint. However, the majority of Muslim/Arab women live conservatively, even in the United States, while keeping to their traditions. Those women get exposed and experience feminism in an abstract new culture, the American. As those traditional women face a new synthetic culture, they either adopt it or escape it. Regardless of their response is, it is their response that I am noting while interacting with them. As an Arab and as an immigrant myself, I share the participants' challenges, fears, aspirations, limitations, dreams, and expectations. I lived in many

Review of Literature

parts of the Middle East and I acknowledge women's roles in Islamic culture and society. I also feel the women's challenges in developing new aspects of life and living in the U.S. Sociologist Collins (1998) described how "women, and especially women researchers", are "outsiders within" (p. 15), and Harding (1991) further explained the concept that "it is when one works on both sides that there emerges the possibility of seeing the relation between dominant activities and beliefs and those that arise on the 'outside.'" (p. 132). That positioned me as a woman researcher whose gender and Islamic Arabian background make her an outsider within looking at Muslim/Arab participants in the study.

I was also interested in knowing how power relations and the individual's social position impacted each participant, a critical understating which was best achieved through their voices. Crotty (1998) described how critical inquiry emphasizes that "particular sets of meanings, because they come into being in and out of the give-and-take of social existence, resists moves toward greater equity, and harbors oppression, manipulation and other modes of injustice and unfreedom" (pp. 59-60). Such a trend of inquiry leads to Freire's pedagogy of critical inquiry that is based on his concept of "conscinetisation." When describing conscientisation, Freire promotes 'critical consciousness', 'critical perception', and 'critical thinking' that perceive reality as process of transformation" (pp. 64-5). Studying the lives of Muslim/Arab women motivated me to understand the women's marginalized lives, their critical concerns, and their feminist aspirations. Alcoff & Potter (1993) suggested that "if feminism is to liberate women, it must address virtually all forms of domination because women fill the ranks of every category of oppressed people. Feminist epistemology seeks to unmake the web of oppressions and reweave the web of life" (p. 4); that was why I chose to seek the women's knowledge though feminist and critical lenses. As van Manen (1990) stated "In education, research which has a critical theory thrust aims at promoting spiritual consciousness,

and struggles to break down the institutional structures and arrangements which reproduce oppressive ideologies and the social inequalities that are sustained and produced by these social structures and ideologies (p. 176).

Conclusion

In this chapter, I examined the works of other authors in order to set the stage for my research question and my findings. My review of literature has responded to the notion of being a Muslim immigrant, how that involved different levels of assimilation and integration, how such levels influence women, how they view the idea of being a part of a foreign environment, and how they interpret the conflict between what they believe and what they witness. The review of literature showed that there were few works in the field of Muslim immigrant women. Those works, in particular, focused predominantly on Muslim/Arab women in Canada, France, or in the United States. Those works were descriptive and focused mainly on women's psychological and social conditions. My study aimed not only to describe the women's experiences, but to serve as a first step in designing a curriculum that will be taught formally or informally to new Muslim/Arab immigrants to the U.S. The chapter also presents my motivations in seeking knowledge from a feminist standpoint and using critical and feminist lenses to understanding the data collected.

3. Methodology And Procedures

While considering any research study, a researcher has to decide on the methodology and the methods s/he will employ, the justification for the choice, the assumption about reality that the researcher brings to the work, and the kind of knowledge the researcher believes will be attained by the research. Crotty (1998) presented three elements that should be taken into consideration when developing any research: the strategies or the plan of action behind the choice of the methods used, the philosophical stance or the theoretical perspective that informs the methods and provides logic to the research, and the theory of knowledge, or the epistemology, that is embedded in the theoretical perspective. However, as an educator and a researcher, I also agreed with van Manen (1990) that the choice of research methods is itself a pedagogic commitment and that it shows how one stands in life as an educator. By using ethnographic methods to study the experiences of Muslim/Arab women who share the same Islamic culture, I chose constructivism as an epistemology, and I positioned my methodology within a research stance that has both feminist and critical lenses. Then I relied heavily on van Manen as my theoretical base for phenomenological inquiry. My aim was to create a "dialogical text which resonates with the experiences of readers, while at the same time, evoking a critical reflexivity about their own pedagogical actions" (Geelan et al., 2001, p. 2). Simply speaking, the methods used to interpret

the experiences of Muslim/Arab women were to listen to, hear, observe, deduce from, understand, and reflect critically on what they say and do.

My research question was how do Muslim women (many of whom are Arab) from different parts of the world encounter conflicts between Islamic traditionalism and feminism in the United States. From their oral histories, I intended to derive meanings from their experiences and their challenges in their new environment. This chapter presents the methodology of approaching the study qualitatively including discussion of the theoretical perspective, sampling strategies, procedure/process, interviews, participants, and issues demonstrating the quality of the study with its limitations.

Approaching the Study Qualitatively

The study was an exploratory and descriptive qualitative interview study through which the researcher sought to understand the meanings of the lived experiences of immigrant Arab/Muslim women in the U.S. Qualitative research was the method of choice for this study because it provides richer and deeper layers of information for any given research question, aspects that traditional quantitative research methods often fail to cover. The participants were chosen purposefully, and not randomly as in a quantitative research, with the intent of acquiring in-depth understanding of their daily experiences.

Sherman and Webb (1988) stated that the key philosophical assumption of all types of qualitative research is based on the view that reality is constructed by individuals interacting with their social worlds. Qualitative researchers are interested in understanding the meanings people have constructed, how they make sense of their world, and the experiences they have in the world. "Qualitative research implies a direct concern with experience as it is 'lived', or 'felt', or 'undergone'" (p. 7). Thus, due to the limited research on Muslim/Arab immigrant women in the U.S., a qualitative approach, with its exploratory,

descriptive, and constructive nature, was ideal in this context.

I found that the qualitative methodology of the research could best describe, in detail, the experiences of the Arab/Muslim immigrant women. Sherman and Webb (1988) agreed that qualitative research is better able to present social issues or anthropological issues stating that "the key philosophical assumption upon which all types of qualitative research are based is the view that reality is constructed by individuals interacting with their social worlds" (p. 4). The methods used in the current study involved conducting interviews, taking field notes, observing, and reflecting with thick descriptions.

Theoretical Perspective

The goal of the study was to communicate the participants' experiences and to bring them to the attention of educators and others interested in the study. I employed both Islamic feminism and critical theory as the theoretical frames for my research. Both theories were behind the methodology of my project "as the theoretical perspective provides a context for the process involved and a basis for its logic and its criteria" (Crotty, 1989, p. 66). The aim of the research was to make sense of, interpret, and understand the experiences of Muslim/Arab women, how their culture molded them, how the new culture affected them, and how they tried to resolve the conflict between traditionalism and feminism in the U.S. The study aimed at "gaining an understanding of the text that is deeper or goes further than the author's meanings or understanding" (Crotty, 1998, p. 91). Such an understanding was best achieved through interpreting the voices of the female participants from a feminist theoretical perspective.

The study aimed to explore the richness and diversity in Islamic feminist thought and what they knew different as women (awkward wording) from men. The participants, were indirectly, "doing" epistemology that "expresses concerns, raises issues, and gains insights that are not generally expressed, raised or gained

by male epistemologists" (Crotty, 1998, p. 174). Thus, I chose to follow the feminist theory which tries to construct knowledge and understand reality from the perspective of women as presented by both Patricia Hill Collins and Sandra Harding in their emphases on feminist standpoint epistemology. Belenky (1997), in Women's Ways of Knowing: The Development of Self, Voice, and Mind, wrote about the epistemological development of women that is appropriate to the objective of my study where knowledge is constructed from experiences of Muslim immigrant women:

All knowledge is constructed, and the knower is an intimate part of the known…To see that all knowledge is construction and that truth is a matter of the context in which it is embedded is to greatly expand the possibilities of how to think about anything, even those things we consider to be the most elementary and obvious. Theories become not truth but models for approximating experience. (pp. 137-138)

While critically analyzing data collected, I as an Arab immigrant to the U.S. acknowledged the context of the research and relied on the emancipatory paradigm criteria. Lincoln (1995) described how positionality or standpoint epistemology emphasizes that "texts cannot claim to contain all universal truth because all knowledge is contextual" (p. 310). My concept of critical theory was based on Freire's "counter-hegemonic theories … in search of new ways of linking social theory to narratives of human freedom" (Cornel West, 1993, xiii Preface). I was very interested in the narratives of the Muslim/Arab women who came from the roads where knowledge, truth, and reality have been fused in one's connection, understanding, realization, and impressions about the things known to them. Giroux (1985) emphasized that there is a need "to work on the experiences that make up the lives of the oppressed. This means that such experiences in their varied cultural forms have to be recovered critically in order to reveal both their strengths and weaknesses" (p. xxiii). The experiences of Muslim/Arab immigrant women

hold much significance to the field as it enriches one's understanding of how female Muslim immigrants succeed in the U.S. despite the hindrances of language, culture, gender, and social class. I presume that we become enriched with the women's oral histories and the new meanings we can get out of the interviews as they reflect the status of Muslim women from many Muslim countries.

Having lived in the Islamic culture and having always been a part of it, I acknowledge that at the core of the Islamic culture is what is best for society and not what is best for the individual. Islam favors the collective good over the individual, preaches for the extended family, and seeks to include all brotherhood in Islam regardless of age, color, ethnicity, or background. Such teachings may repress individuality and present us with generations who faithfully make meaning of their lives by reliving the lives of their parents so that the cycle goes on encompassing believers in the collective good of the community, the "umma" of Islam. Ortega y Gasset (1958) described inherited and prevailing meanings as 'masks' and 'screens,' and warns us that, instead of engaging with the world, we find ourselves "living on top of a culture that has already become false …. man has gotten away from himself, separated himself from himself; culture intervenes between the real world and his real person" (pp. 99-101). Such may well be the case with the majority of Muslim men and women whose attachment to culture provides them with security and belonging and may take away their personal vision and voice.

Why van Manen's Approach?

I believe that the phenomenological inquiry was the most appropriate approach to meet my study's objectives. Van Manen (1990) defined phenomenological inquiry as the study of the life world with the goal of describing (phenomenology) that is tentative to how things appear and to let things speak for themselves. The term implies that the "facts" of lived experiences are always already meaningful experiences (p. 180). Van Manen

further invited researchers to have their texts oriented in a pedagogic way, as is my intention for a later curriculum for Muslim immigrant women: "To be oriented as researchers or theorists means that we do not separate theory from life, the public from the private. We are not simply being pedagogues here and researchers there-we are researchers oriented to the world in a pedagogic way" (van Manen, 1999, p. 151). Since the study aimed at a rigorous effort to understand the life-world of participants from the perspective of the participants, (Pinar, et al., 2000; Schwandt, 2001), I believe that phenomenological inquiry was appropriate to meet my objectives.

Dilthey (1985) affirmed that "a lived experience does not confront me as something perceived or represented; it is not given to me, but the reality of lived experiences is there-formed because I have a reflective awareness of it" (p. 223).

Thus, a lived experience cannot be understood "in its immediate manifestation, but only reflectively… as we relate the particular to the universal, part to whole, episode to totality." (van Manen, 1990, p. 36).

Research Context

I was interested in understanding the challenges of Muslim/Arab immigrant women in the United States primarily because this is where the majority of my own experience lies. I lived my life in Lebanon and Iraq, studied in Egypt and Tunisia, and learned much about Muslim women in different countries. Now in the U.S., I not only share their experiences but have the opportunity to further study and research them in a way that can lead to a curriculum that can help other new immigrants.

Sampling Strategies & the Participants

The data collected was within the interpretive/constructivist paradigm, so I used a theoretical and purposeful approach to sampling. Denzin and Lincoln (1994) described how within such

a paradigm, the sampling activities begin with an identification of "groups, settings, and individuals where (and for whom) the processes being studied are most likely to occur" (p. 202). Since my study was about Muslim/Arab women, I looked for individuals who were Muslims, Arabs, either or both. As I had to choose from a group of Muslim/Arab women, I searched with the theoretical-purposive approach to keep my study within the emancipatory paradigm where I could work with a "distinctive consciousness of representing the populations that has traditionally been underrepresented in research," (Mertens, 1998, p. 254), namely Muslims, women, and immigrants. A key informant, Uleban, who was a leader of the women's circle in the Muslim community, helped me choose my participants for the study. Following snowball or chain sampling, my key informant recommended and referred me to other potential participants. I chose married and unmarried Muslim women born in Arabia or in Muslim countries and currently living in one state in the United States. I realize, from my first-hand experience as an immigrant Arab woman, that those who were born in Arabia or in Muslim countries share authentic cultural experiences that the second or third immigrant generations do not experience.

I conducted semi-structured interviews with ten women in Tulsa, Oklahoma, from June 2004 to May 2005. All the participants were first generation immigrant Muslims who came from the United Arab Emirates, India, Lebanon, Cyprus, Turkey, Jordan, Iraq, Syria, Iran, and Egypt. I deliberately sought a sample that varies by country of origin, time spent in the U.S., level of education, profession, ethnicity (Arabs and non-Arabs), and number of children. I believe that differences in social class, country, and profession influence identity process, success in the U.S., and the level of tension associated with acculturation and assimilation. What was common among all the participants was that they shared the Islamic religion and culture, and they all lived in the U.S., with the exception of Suae who came as a student and retuned to her homeland after graduation. I also

tried for more than six months to schedule an interview with a Yemeni woman, but she was a mother of five with a full-time teaching job and was pregnant. I gave up, realizing how busy she was and was content with ten participants.

The Procedure/Process

I began soliciting participants in June 2004 and met with my first participant at a university lecture. She was a graduate student from the United Arab Emirates who won a scholarship to pursue studies in the U.S. as a graduate. Her personality and her attire impressed me, and I decided to include her in the study if she agreed. Finding women from the United Arab Emirates was not easy in the state where I conducted the study, so Suae was an opportunity for me. I called her first and discussed the possibility of her participation. I read her the form that can be found in Appendix B. Since I understand the culture, we had to meet at least once before I conducted business (business in Islam comes next to socializing). I knew that I had to make her feel comfortable and trusting as a way of establishing reciprocity and developing a sense of mutuality. Later I conducted two interviews with Suae, one at the university and another at her home.

Five participants from Iraq, Yemen, Egypt, Jordan, and India were recruited through Uleban, who is a leader in the mosque. It was by accident that I called Uleban to ask her if she was willing to help with my study. I told her that I was looking for more Muslim/Arab women in the area. She listed at least fifteen women from different countries and joked about the mosque having international representatives from all over the world. It was then that I decided to seek voices that we normally do not hear: women's voices from either Yemen or India are not ordinarily sought and found. I felt lucky. I asked Uleban to call the women and to introduce me as a person first and as a researcher second. She graciously did, and I felt more comfortable calling them after. I knew that Muslim women, usually, need to discuss their participation with their husbands first, and I knew that I had

to prove that I am trustworthy and had a good cause to enter their homes and to take their time and stories. The other three participants from Turkey, Iran, and Cyprus were personal friends who were willing to participate in the study.

All the interviews, with the exceptions of Suae and Sjordan, were conducted at the interviewees' homes. Most of the interviews lasted more than two hours each. I conducted eight interviews in English, and two in Arabic. I introduced the subject of the study to every participant and asked them to sign consent forms (see Appendix A for form of consent). I only had to translate for Ziraq because I conducted the interview in Arabic. All participants followed the same interview protocol with some variations as presented in Appendix C. When I called the participants, I read them the invitation letter (See Appendix B) and asked them if they agreed to it. There were many times when the appointment date was cancelled at the last minute, or when two participants were not in town. However, I kept persevering until I completed all the interviews.

During the interviews, I met three of the participants' husbands. Rindia's husband, who was present during a part of the interview, was very interested in the project and even participated in answering many questions that I asked his wife. Sjordan's husband met me at work as we both taught at a college, and Uleban's husband was also excited about the study and wanted his wife to participate, acknowledging that few studies were conducted on Muslim/Arab women. Keeping their trust and appreciating their willingness to help made me focus even more seriously on my credibility and all the ethical rules of research.

The Interviews/Data Collection

The interviews contained open-ended questions about general topics in the participants' lives such as cultural behavior, children's education, gender roles, level of assimilation, effects of religion on their lives, what the veil meant to them, and how close to

traditionalism they were still livinig their lives in the United States (see Appendix C: Interview Protocol). The study followed an interpretive design based on semi-structured interviews with respondents in their convenient settings of home or office. Follow-up interviews were conducted in order to clarify unclear points and to identify changes in the participant's responses and the individual's changes over time.

Although the protocol provided a valuable structure while conducting the interviews, the interviews still were guided by the participant's responses that presented new questions and new data. This flexible approach to data collection was encouraged by Blumer (1969) and Glaser and Strauss (1969). The question must be approached "through the eyes and experience" of those who lived it, and the "direction of inquiry, data, analytic relations, and interpretations arise out of, and remain grounded in, the empirical life under study" (p. 139; p.40).

The interview procedure allowed me to ask each Arab/Muslim participant questions that involved the background of the participant, the reasons for her immigration to the U.S., the conditions and the challenges that she encountered then and now, and the hopes that she aimed for in expressing herself and her voice. There were questions on how far each participant was committed to traditional Islam, what she kept of the rituals, how she taught her children about her culture and language, what changes she wished to see, and how she considered feminism in the new environment. Every Arab/Muslim participant signed a consent letter for adult participation and was given a copy of the protocol as I worked one-on-one with her.

The participants provided stories from their lives on the pressures, tensions, and challenges they faced as Muslims/Arabs, as women, and as immigrants in a foreign culture. They responded to how ill/well they faced such dilemmas. The interviews presented a comparison between the participants' lives back in their homelands and their lives in the U.S. Such comparisons enabled me to realize how their lives changed

and how they acquired new meanings to new concepts in the U.S. The participants discussed the changes that were needed (like driving and working), the changes that they rejected (like modernism and liberal feminism), changes that were important to their survival (like acquiring a new language and understanding the educational system for their children), and changes that were debatable (like food, clothes, the veil, and even a new understating of the Quran).

With each interview, I started acknowledging which questions meant more to most of them, and which meant less. The interviews showed that the women's lives were very complex, and reinforced what van Manen (1990) described as hermeneutic-phenomenology in which the researcher seeks to "accomplish the impossible; to construct a full interpretive description of some aspect of the life world, and yet to remain aware that lived life is always more complex than any explication of meaning can reveal ... full or final descriptions are unattainable" (p. 18).

During the interviews, I audio-taped and took detailed notes (I do not trust machines); so after each interview, I had an audio tape and many pages of notes to consider. I made sure to transcribe each interview on the same day in order to be fair to the information and in order to include what was said without saying (things I remembered, body language, gestures, and certain comments). Although I was recording the interview, I still took notes and wrote as much as I could from the interview. Once I was home, I would rush to my room to write my feelings and comments before I forgot them. I considered everything significant, even the way my tea was served by the women, and I recorded the smallest things (like the ornaments in the house and what hung on the walls). I wrote quickly and never cared about the many spelling mistakes; after all, I was the only one who was going to decipher the notes later. Once I was back from an interview, I first recorded my thoughts and feelings by the margins of the notes taken. I kept copies of the work on back up files, on flash drive, and hard copies. The participants received

copies of the interviews in order to check the accuracy of what they told me.

Data Analysis

The preceding review of literature situated my study within a certain body of knowledge. The experiences reported by Muslim immigrant women who participated in the study reflected their levels of adaptation, assimilation, integration, as well as their voices of feminism. In addition, the construction of this review also influenced my assumptions, perceptions, and conceptions of reflective experiences of Muslim/Arab women in the U.S. because it offered categories that structured and guided my analysis.

Data analysis was guided by the work of van Manen (1990). Van Manen suggested considering text (data) "in terms of meaning units, structures of meaning, or themes" (p. 78), and noted that "phenomenological themes may be understood as the structures of experience" (p.79). I approached the data from different directions to uncover themes. I read the entire text of all interview transcripts, observations, and documents to glean meaning from the reading. During this holistic reading, notes were made on the text to record potential themes that appeared in the data. I also read the text another time and highlighted portions that seemed relevant to the categories that I chose from the review. During this detailed reading, I looked for meaning in each sentence or cluster of words. The highlighted portions were also labeled to provide a concise statement of the meaning. A third selective reading was done to look for specific instances of themes that were prevalent. I underlined those and set a table that included the origin of birth, social class, level of education, level of integration, and number of children, as factors in finding common themes. Such reading helped me to focus themes that seemed vague or disconnected. The themes resulting from these various readings were sorted and rearranged, as I combined and collapsed them into one another.

From the themes came thematic formulations or thematic analytical statements. I made a written record of these which I returned to as the analysis progressed. The statements were modified to reflect the clarity gained during the evolving analysis. These statements, like the ones on veiling, arranged marriages, and levels of integration, were then captured in more comprehensive notes or memos. At various times during analysis, the developing themes became the focus of questions in follow-up interviews. Such a recursive process allowed me to determine whether the theme was essential to the meaning I was seeking or incidental. Adding to this process, I went to peers for a different perspective on my speculative themes. I discussed the themes with two friends, one from the college of education and another who was a professor from Palestine whose first-hand experiences with Muslim women in Arabia was much appreciated. I used this validation or contradiction to expand, modify, reevaluate, or eliminate a theme.

Judging the Rigor of the Study

Research Subjectivity. My study was prompted by personal experience with Arab/Islamic culture, one that I lived, understand, and appreciate. From the perspective of an Arab, a woman, an immigrant, and a researcher, I have witnessed the urgency of understanding the lives of immigrant Arab women in the hopes of creating curricula that can ease their integration in the new American culture. Thus, the study was promoted by my first-hand experience in the U.S. and from my understating of the Arab Muslim world, women in particular. According to van Manen (1990), prior to beginning the inquiry, our assumptions and pre-understandings should be acknowledged:

The problem of phenomenological inquiry is not always that we know too little about the phenomenon we wish to investigate, but that we know too much.... Our "common sense" pre-understandings, our suppositions, assumptions, and the existing bodies of scientific knowledge, predispose us to interpret the

nature of the phenomenon before we have even come to grips with the significance of the phenomenological question. (p. 46)

Prior to working on this project, I started with a pilot study that involved four Muslim women from Syria, Iraq, Turkey, and Lebanon on the importance of literacy in their lives, and that prompted more issues of interest and led to the study at hand. The pilot indicated that there were more important issues to the women's lives as immigrants than their literacy. I felt that the women shared cultural tension, fear of change, hesitation in adapting, and conflicts in what to choose from the new culture. The women in the pilot were excited that someone was trying to listen, acknowledge their anticipation, and appreciate their daily experiences. The pilot study encouraged me to research more diverse Muslim/Arab women and explore their personal knowledge and experiences into a context that could transform the experiences from personal to a text that could be taught academically or for adult learning in educational centers.

Maintaining Trustworthiness. The framework presented by Lincoln and Guba (1985) of credibility, transferability, dependability, and confirmability was achieved by implementation of the following measures for judging quality in qualitative research: prolonged engagement, persisted observation, peer debriefing, negative case analysis, member checks, progressive subjectivity, and triangulation.

As to the credibility of the study, Mertens (1998) acknowledged that in "qualitative research, the credibility test asks if there is a correspondence between the way the respondents actually perceive social constructs and the way the researcher portrays their viewpoints" (p. 181). Credibility of the study was achieved through the use of multiple strategies that I utilized in my study. I ensured a prolonged, substantial engagement with my participants, met a few times with each and discussed many concerns that related to their lives even before tape recording the interviews. I stayed in touch for several months following up on

what they wished to share, which facilitated the development of a deeper understanding of the participants' knowledge and concerns. Persistent observation was exhibited through the thorough recording of the face-to-face interviews. As for peer briefing, I engaged in an extended discussion with a disinterested peer concerning findings, conclusions, analysis, and hypotheses. However, as Lincoln and Guba (1985) affirmed, "no amount of trustworthiness techniques built into a study would ever 'compel' anyone to accept the results of the inquiry; it could at best persuade" (p. 329).

Transferability was achieved through a thick description of the research process to allow readers to see if the results can be transferred to a different setting and is parallel to external validity in postpositivist research (Guba and Lincoln, 1989). In my study, I tried to provide sufficient details to enable the reader to make such a judgment through careful description of the time, place, context, and culture of the diverse population of the participants. Lincoln and Guba (1985) stated, "It is not the naturalist's task to provide an index of transferability, but it is his or her responsibility to provide the data base that makes transferability judgments possible on the part of potential appliers" (p. 316). Since the participants in the study came from different Muslim/Arab countries, the "purposive sampling affected the feasibility of generalizing to other environments" (Creswell, 1994, p. 27). Still, the burden of generalization lies with the readers, who are assumed to be able to generalize subjectively from the case in question to their own personal experiences (Stake, 1994). In such a case, I had an obligation and a task to provide the reader with sufficient "thick description" about the case so that the reader can understand the contextual variables operating in that setting (Guba & Lincoln, 1989).

Dependability is parallel to reliability in the positivist paradigm which is used to attest to the quality and appropriateness of the inquiry process (Guba and Lincoln, 1989). Member checking was the most important criteria

that I utilized to maintain credibility. After every interview, I summarized what had been said to the participant and asked if the summary reflected her position on the themes we discussed. After transcribing the interview of each participant, I sent a copy of the final transcription to the participant involved.

Confirmability, to Guba and Lincoln (1989), meant that the data and their interpretation were not figments of the researcher's imagination, and that it could be tracked to its source. Data gathered and processes undertaken in this study – the raw data (field notes and audio-recordings); data reduction and analysis products (summaries, themes identification); data reconstruction and synthesis products (clustering of themes into categories, interpretations, and final report); process notes (methodological notes and trustworthiness notes); information about intentions and disposition (research proposal); and reflexive journal – amounted to a "chain of evidence" (Yin, 1994) that confirmed trustworthiness.

Confidentiality: In planning the procedures of my study, two factors were important ethically and legally. Gay (1996) stated that ethical concerns are more acute in experimental studies which, by definition, "manipulate" and "control" participants. The foremost rule of ethics that I kept was not causing any harm (physical and mental) to any of my participants. Thus, I kept all information or data either from or about a subject strictly confidential. The bottom line principles and laws relating to ethics of research with human participants are "respect and concern for the dignity and welfare of the people who participate" (Gay, 1996, p. 85). Mertens (1998) summarized how researchers should treat participants by "debriefing the research participants after the research study (the researcher explains the real purpose and use of the research), by guarding the privacy and confidentiality of the research participants, and by obtaining fully informed consent" (p. 25). I further was aware that my relationship with my participants should not be one of colonizers, a fear Villenas (1996) presented "by objectifying

the subjectivities of the researched, by assuming authority, and by not questioning their own privileged positions, [researchers] have participated as colonizers of the researched" (p. 713). Thus, I kept a conscientious, friendly, and respectful relationship with all participants by calling them on special occasions which encouraged other Arab/Muslim women to volunteer for future projects.

Confidentiality was further ensured by my handling of the data. At the conclusion of the study, the interview tapes were destroyed. In order to protect participants' identities, I assigned pseudonyms that had first initials of the names and the name of their countries in order to ease traceability, e.g. Ziraq from Iraq. It is a way that allows the reader to realize the country of the participant without having to remember the name. All information collected and the list indicating actual names were kept in a secure place only at the interviewer's residence. Other than the sole interviewer, no other person was made aware of participants' identities. The study may result in published articles, books, and presentations at professional conferences. Any reporting that arises from this research project will not identify individuals, places, names, or events.

Limitations. I was limited by time and space to cover all the aspects of the curriculum that was the later objective of the study. Changing the lived experiences of the participants into text did not provide all that was needed to complete the basic components of a new curriculum. Mertens (1998) warned that it is unlikely to "design and conduct the 'perfect' research study in education" (p. 345). I tried to include diverse Muslim/Arab women, but I failed to include all, especially Muslim women from China and the previous Soviet Union. Including one participant from every Muslim country was enticing, but after interviewing ten women, the data collected and the themes derived started to look unmanageable and unfit within the scope of this study.

Conclusion

I had an ethical responsibility as a researcher to protect the identity and the content of the data collected from the lived experiences of the Muslim/Arab women participants. I followed a strict procedure in keeping the participants informed and in ensuring their confidentiality. The preceding methodology addresses all those issues and all were approved by the Oklahoma State University Institutional Review Board. A copy of this approval is included in Appendix F. I conducted follow-up interviews with respondents in order to clarify unclear points and to identify changes in the participants' responses and the individuals' changes over time. My questions were about the participants' background, reasons for immigrating to the U.S., levels of integrations, conditions, hopes, and the challenges that each participant encountered then and now. As a researcher, I tried my best to present a study that was ethical, credible, and trustworthy.

4. Findings

Muslim/Arab women in America encounter a unique set of cultural and educational challenges as will be evident in this chapter. A study of their experiences is bound to reveal a core of conflicts and resolutions as the women achieve deeper meaning in their encounters between the traditionalism inherent in their foundational cultures and the feminism presented in their new environment. Muslim/Arab women face an extensive frame of liberties and opportunities available to American women which many of these deeply religious women characterize as radical. From what the participants shared, we can hope to understand the distinction between reality or facts and assumptions about Muslim immigrant women in the United States.

What They Said & What I Learned

Given the diverse backgrounds, it was no wonder that the participants posed different sides on different issues. It was clear that those women shared Islamic faith and traditions rooted in religious doctrines, but all realized that they could not reproduce their traditions in an environment that demanded divergent thinking. This chapter deals with the recounted experiences of the participants as they found themselves between the two cultures – the traditional and the host – and taking what worked for them from each.

What the participants said was enriching and exciting. I enjoyed the interviews, not only because of the data I collected, but because they gave me the opportunity to get closer to my participants, feel their emotions, dream their aspirations, and admire their courage and resilience. What they conveyed through their stories was narrational, more natural and less formal. In Acts of Meaning, Bruner (1990) presented how while logical analysis "proves" an idea or concept to be right or wrong, "narrative negotiates passages between what we understand and what we do not understand but to which we are attracted. In short, narrative-living … is a chief vehicle for helping people grow, expand their horizon or zones, and come in a meaningful contact what the nocanonical." (p. 55).

Descriptions of the Study Participants

The description of the participants that I am presenting in this chapter primarily reflected the experiences of the ten women in the study as well as the interpretations of some of these experiences as recounted to me in conversations. The participants consisted of ten Muslim/Arab women whose homes were the United Arab Emirates, Syria, Cyprus, Iran, Jordan, Turkey, India, Lebanon, Egypt, and Iraq. In the course of two years, it was the women who were my principal informants and who shared about the challenges in the U.S. as they struggle to make sense of their experiences in this country, their feelings, dreams, and frustrations. The ten participants reflected on the conflicts they encountered, which were posed by the divergence between their traditional Muslim/Arab socialization and the pro-feminist socio-cultural orientation in American society.

I chose married and unmarried Muslim/Arab women born in Arabia or in Muslim countries currently living in Oklahoma. They had experienced the authentic life of women in Islam. The sample of interviews was diverse as I searched for differences and similarities that existed among the ten participants. Common elements that they shared were their Islamic religion, residing in

America, and the tension they experienced with acculturation. Some participants knew Arabic, some understood but did not write the language, and some did not know Arabic at all except for the terms they had memorized from the Quran.

I conducted interviews, took field-notes, translated from and into Arabic, and transcribed into English. Who to first interview was an urgent decision that I contemplated for a time. Since the participants are from different countries, I decided to start with the ones who could meet with me sooner. My first interview was with a Muslim/Arab young lady from the United Arab Emirates. I was anxious to meet with her once I realized that she was to go back home in a month. I felt that a participant from the United Arab Emirates could share special experiences of the new modern nation that is much involved in women's rights and laws.

As I selected a number of participants, not only did I consider the different countries, but also their social class. When I wanted a participant from Turkey and from Cyprus, I had many to choose from. However, I chose a participant who decided to work outside the home, even with her limitations of language, and another who decided to be a housewife even when she had a degree in nursing from an American college. A friend of mine, from Syria, suggested that I include a potentially interesting participant from Lebanon.

I decided to include women from a mosque in Tulsa. I met a Lebanese woman who was a leader for the women's circle at the mosque and who gave lessons on the Quran and Arabic to other Muslim women. She was both willing to participate and to introduce me to other potential participants.

Demographic and Individual Descriptions of Participants

A short biography on every participant mirrors the effects of the background, process to adaptation, hindrances, beliefs, hopes and the objectives of each. The following pages are filled with experiences of Muslim/Arab women who have lived with

tensions in a new environment, and who responded creatively to new situations. Their stories are testimonies of what it has meant and what it means to be a Muslim and an Arab in the United States. My participants were all of Muslim origins, but they were not Arab Americans who were born in the U.S. I believe that the experiences of second or third generation of immigrants would be very different from women who were born in the Arab/Muslim world.

Suae (United Arab Emirates): I first met Suae at a meeting at Oklahoma State University. The speakers were professors who spent the last two years at the United Arab Emirates. They established a new college for girls, and were excited with their experiences there. Suae was one of the pioneer girls at the college in the United Arab Emirates, and when an announcement of a scholarship for a Master's Degree was publicized, Suae convinced her parents that she should apply. Suae was accepted, and she enrolled in college in International Studies. It was there that I met a young lady with a nice headdress and a sweet smile. Suae was twenty-three years old, single, religious, traditional, and ambitious. Although she did not go to the mosque, she kept all the religious practices of prayers, fasting, and others. Back home Suae helped babysitting her sisters, helped with their studies, and read a lot. She stated that she was very responsible with her family and studies and that she went to the gym and did community service project like bazaars and fundraising activities. In the U.A.E., all her friends were females, but she had part-time jobs and internships in places with men. Suae's mother was a dentist, her father was an accountant who was educated in England, her grandfather was a school principal, and she had a surgeon, a dermatologist, a teacher, and a dentist as uncles and aunts. Thus, every member of the family was expected to be highly educated.

Suae told me of the many possibilities for women to work in the United Arab Emerites and informed me about the laws

and constitution that support women. Suae's sister was a dentist in the military, and the U.A.E. was the first Muslim country to have a military college for women. In her studies Suae worked on research about Muslim women in the Muslim world. However, she emphasized the importance of making decisions collectively and believed that women needed to be protected by families. She believed in arranged marriages and that women should not live on their own. Suae felt free to do whatever she wanted but she felt committed to discuss all her decisions with her father first, because she "owed him responsibility since she carried his name."

Suae was a smart young woman who spoke perfect English and who was very organized. It amazed me how she kept copies of everything she did ranging from checks, to traveling tickets, to bills, to even the interview that we conducted. Suae was popular among all her friends, and she was proud of her headscarf, traditions, religion, culture, and family. It was interesting how Suae declared that where she was from "there are big sets of rules to follow, but here, you should depend on yourself and find the best way." Suae spent two years in the U.S. She intended to be back for her doctoral degree, but she said that she might be ready to get married at that age, and then later pursue her higher education.

Syra (Syria): Syra was a sweet lady from Damascus, Syria. Syra was in her early thirties and we met over a cup of coffee to talk about her life in Syria and in the U.S. Syra informed me that she learned to recite the Holy Quran by the age of three and used to pray with her mother following the whole ritual and traditions of praying five times a day. That was all before she went to school. Syra was the youngest in a family of five girls and two boys. Her father was a local businessman who worked on oriental furniture selling and fixing for profit. He was skillful but with a big family and did not pay much attention to their education. His plan was to train his sons to follow in his footsteps, while the girls learned

how to sew and how to do domestic work. All Syra's sisters were skillful in sewing and in beading. From an early age, Syra used to be a hand to her sisters who were constantly under pressure with much sewing and beading. She thought it was fun to help out but it turned out that she too became such a handy lady and her home was filled with creative works. Syra went with her sisters to a neighborhood elementary school, but there was little emphasis on reading or writing, let alone on foreign languages. Syra got her high-school degree but she always felt that she did not get much from her education.

By the age of twenty, Syra got engaged for a year and then got married. She joined her husband, a Syrian who owned a restaurant, in the U.S. The marriage was arranged between the two families, and Syra first met her husband in America. At the time we met, Syra had three children, two boys and a girl ages twelve, ten, and six. The boys attended the Muslim Academy where they studied Arabic and Islamic religion along with other courses, and Syra drove them daily to school and picked them up. When I first met Syra at a tea-party with other Arab women, she stood out as a motivated, beautiful woman who had a desire to learn. Two years ago, Syra started taking English lessons in a nearby church and she started visiting the libraries as often as her time permitted.

When I asked Syra about how she felt about marrying someone she did not meet before, she stated that she felt "anxious and uncertain," but she was always assured by her family that she was doing the right thing. Syra detailed how "his family arranged the marriage … [how] he could not get to Syria … and [how] his parents signed a contract to marry them." On the issue of veil, Syra chose to wear it after being in the states for a few years. Her husband was not happy with her decision at first, but then "he felt better." Syra believed that "the veil protected a woman and her traditions of avoiding problems like 'fitna' among men (struggles rooted in women's looks)." To her, the veil provided "psychological comfort," and it made her feel "safe and secure."

[Margin note: Confused about her husband]

Syra felt a "little intimated" after the 9/11 bombing of New York.

Syra considered it an achievement that her husband started fasting and praying. He also stopped drinking as he saw his wife's diligent prayers five times a day. Syra believed that it was "her duty to make her children pray." As for her children's education, Syra spent much of the family's income on the Islamic Academy where her children study. She believed that the money was worth it since her kids could "keep the Arabic language," and they could feel protected within an "Islamic society." Syra wished to learn enough English to understand the interesting news on CNN and on Discovery Channel. Syra loved shopping, but she avoided communicating with anyone due to her language. For the future she planned to improve her language and to learn computer skills.

[Margin note: driven, individualized, traditional to a point]

Dturk (Turkey): Dturk was a striking, ambitious, thirty-five-year old mother of two girls. She was determined to succeed and wanted to be influential in bringing more of her family members to the U.S. Dturk started working two jobs (baby-sitting in churches) before she knew much about the language, place, and culture. From the start, she wished to save money to go to college. Dturk was pregnant when she first arrived. She had won, by lottery, visas for residency in the U.S, and considered that God gave her a special opportunity and decided to make the best out of it. As I talked to Dturk, I felt her passion to accomplish things as if she were on a mission. Her motto was to "do whatever it took to succeed in the land of opportunity."

Dturk was born in Iskandaroun, a beautiful port city along the Mediterranean Sea. Tourists from all around come to enjoy the sea and that was a reason for the growth of the city and the various languages its inhabitants seem to understand. Iskandaroun was part of Syria prior to 1939 when the Ottoman granted the city to Turkey. Dturk was familiar with the Arabic language, but she only spoke Turkish, the language of schools

67

and society for her age. Dturk had been in America for six years when her husband got the opportunity of serving in the military in Iraq, and she insisted that he leave as she felt able to take care of the family without a husband.

Dturk studied three years at the university in Turkey and got married before finishing a degree in business. In the U.S., her daily activities were driving children to school, preparing meals, baby-sitting when needed, and attending night courses. She took care of the bills and of the family's needs. When I asked her how she felt when her husband left, she told me that when they were in Turkey, her husband found a job in Russia, and she insisted that he take it. During his absence, she took care of the gift-shop that they had. Here in the U.S., he did not want her to work because of the children, but she "did not have to listen to him," and he agreed later. Dturk did not believe in the value of a veil nor did she wear it. She prayed, fasted, and paid alms, and chose to stay in the U.S. while her husband left to Iraq. Dturk never felt silenced by her husband; on the contrary, she always had her ways in voicing her wishes and of making everyone "listen to her."

Dturk valued her freedom in the U.S. She chose what to change and what to adapt from the Western American culture. She had many American friends and she fitted well with them. However, she feared, like all Muslims, that her daughters would live alone when they became of age, and that "was scary for [her]." Dturk was afraid for her children "being with the wrong crowd. Drinking and sex were things that scared [her]." Every summer Dturk took the family to Turkey to spend three months with her sisters and parents regardless of cost and time. Dturk believed in education and in the value of work and she refused to stay home doing the daily routine chores. She emphasized that "work gave [her] a sense of value and a sense of achievement," a very American aspiration. Dturk and her husband were never involved in a mosque and did not believe in veiling; however, they both agreed on an arranged marriage blessed by their

68

families back in Turkey. The Muslims they socialized with were friends from Turkey or from Cyprus who were more integrated in the American society.

[handwritten: unmotivated, helpless, traditional]

Ziraq (Iraq): Ziraq, a tall woman with a gentle, shy smile, was 22 years old, with a beautiful daughter, age 2. With her husband in the United States working and sending back money to his family in Iraq, Ziraq had to come to the U.S. alone after an arranged marriage by both sides of the family. Ziraq was quiet and with little self-confidence. She rarely spoke out in any group setting and was not very comfortable when we started the interview. Soon, she felt better. When I phoned Ziraq to inform her about my study, her first response was that she knew little, had been in the U.S. for a short time, and had no good idea that might help the study. As I assured her that she was ideal for my study, she felt more at ease and agreed that we meet. She requested that I meet at her place, that I do not request her to drive somewhere to meet with me, that I am not to talk politics, that I am not to record the interview, and that noon time was convenient because it was the time for her daughter's nap. I was glad to agree to all. She felt particularly comfortable once I started talking in her own language and dialect. I conducted the interview in Arabic and took notes.

[handwritten margin: old school]

Ziraq was from South Iraq and she had been in the U.S. for three years. Her brother-in-law arranged the marriage with her family as her husband could not trust the safety in Iraq. So, those involved in the marriage met in Syria, and she waited for the immigration process for her papers. It was interesting to know that Ziraq attended school up to the Intermediate level, and then decided, due to problems in the English class, to drop out. Her family, being religious and not interested much in teaching girls, directly agreed to her decision. Ironically, she married someone in America and needed to know English more than anything else. Her primary responsibility in the U.S. was to take care of her daughter. She did not drive and had no idea of what was out

there in society. Ziraq missed her family and friends and was facing problems being alone with her daughter every day. She prayed that by the time her daughter would be ready for school, that she would have understood more about American society.

To kill time, Ziraq helped with her husband's work in an ethnic market shop. The majority of customers were Arabs or Muslims, and Ziraq had the opportunity to deal with them. Her English language was improving and she memorized the names of everything they sold in the shop. When I asked Ziraq about the challenges she faced in the U.S., she passionately, responded:

Here, time is valuable, not in Iraq. Here our responsibilities affect our living, not in Iraq. Here my husband works more than 50 hours/week, not in Iraq. Here I have to leave bed early and run to finish all the housework in case I am needed in the store. Not in Iraq where I take hours to drink tea with all members of the family and with the neighbors.

When I asked her what she did if she had questions and concerns about living in the U.S., she simply said that she had to wait for her husband to tell her, or she could ask her brother or mother-in-law. The women in the mosque helped with what they knew, but they also had their limitations. So, she got bits of information from here and there and she tried to make sense of them. Ziraq acknowledged the openness of American society to include newcomers, but she had mixed feelings about her being in the States.

I do not know if I am lucky, but up to this time, I do not have to change much to fit in America. I think it is because my daughter is still very young and we do not have to face schools, friends, teachers and others. My life is limited now to the home and to the business. But, I am ignorant and tense every time I think that I need to know and do more for the future of my daughter. I need to start preparing myself for more about American society, but I really do not know how

About how supportive her husband was, Ziraq emphasized that he was a good man, a hard worker, and a good provider

for them. She justified how he "could not do much to [her] in education … [she] needed time to figure out what to do here [U.S.] now that [she] was sure that [she] would be spending many years of [her] life.

Ziraq was most interesting as she guided me to needs of new immigrant women to the States, and as she truthfully expressed her feelings and fears. When I asked her what subjects she enjoyed most in the circle of women in the mosque, she described how they "teach where to go to get better and cheaper shopping, who is an Arab doctor they trusted and could understand our language and situation, what to do if a police stopped us when driving, who to visit and help at a certain time, where was a good school for children, and many lessons from Quran."

What made Ziraq happy in the U.S. were "safety from bombs and making money. For a long time we did not have any in Iraq." She believed that Allah will send someone to her to help with her driving and education. Ziraq liked to sing and to draw, but she was not doing either then. When I asked her about her perceptions of what life in the U.S. would be like, Ziraq responded that it was not a good one:

We thought that American women are too free and they do not have limits. We thought that men always drink, and children are on their own. But now, I see that they are free and different, and I do not wish to be like them. My family comes first always, not me first. We watch TV and see women in swimsuit with men, men with men, children on drugs, young people drinking everywhere, and we are shocked. I cannot imagine such a life. I am afraid for my daughter, and I prefer to stay home. This scares me to bring up a daughter in America. What scares me more is that I do not know how to make myself stronger in this environment. I do not know how to seek help or where.

Ziraq's sense of helplessness, dreams, and fears touched me. Ziraq did not change much to fit in the American society; however, her views and status changed: "I have not changed much. But I can say that I changed my views about American

women, and I am stronger in dealing with my husband here than a woman in Iraq. I find that he listens to me when I object on any problem. Not in Iraq."

On the subject of veil, Ziraq believed that the veil was a part of her as she wore it all her life, and with a veil, she looked "modest…just like all other women in the mosque". The veil eliminated the need for "make-up or a big budget for clothes." Wearing hijab, in Ziraq's point of view, protected women against "rape due to attractions from shorts to mini skirts to bathing suits."

educated, insightful, islamic feminist

Aegypt (Egypt): Aegypt was forty-seven when we met in an office at the same university where I studied. She was interested to be interviewed and hoped to voice her opinion about being an Arab Muslim woman in the U.S. Aegypt was a mother of five (four girls and one boy), with ages ranging from six to seventeen. Aegypt was insightful and believed that she should voice her views about Islam with pride. She was a cheerful woman and full of fun. Aegypt's husband was a doctoral student in the College of Business and she came to the U.S. after getting married, leaving a medical career behind. Aegypt graduated from a medical school in Egypt, and was a doctoral student in Nutritional Science in the U.S. She loved research and considered it "a mind challenge." She taught and researched at the university while working on her dissertation. However, Aegypt led a life, like many of the Muslim women, of believing in the roles of sexes: cooking, driving the children to schools, teaching them, and taking them to the mosque; the last role was a committed duty to her being a Muslim mother. She missed home and her mother and used to take the family back to Egypt almost every summer to keep the children in contact with their language and religion.

Aegypt described her experience when she was eighteen; a new medical student left with a cadaver of a beautiful woman, she realized that there must be more in life than our bodies. She decided "to recalculate [her] life" and search for more value in

the soul. As for the veil that she wore, Aegypt described how her "husband liked the behavior, and saw that this was a sign of a good woman, wife, and mother. I felt that it was okay with him that I wore it." She decided to focus on the soul and started wearing a head-scarf. Aegypt believed that as a Muslim, she paid attention to all the demands of Islam: prayers, fasting, paying alms, and considering pilgrimage to Mecca. She insisted that she tried to lead her life according to "the book," meaning the Quran. Her husband shared the same values and practices. Aegypt had many American friends, and she loved the diversity the place presented. She dutifully took her children to the mosque to help them grow spiritually and socially. Aegypt acknowledged that the hijab caused a challenge and so did discrimination against her ethnicity and religion. Aegypt believed in the third voice of feminism in Islam, not the traditional, nor the dominant feminism, but one that was led by Heba Ra'uf Ezzat: A voice of feminism that was parallel to feminism in Iran and encouraged reform from within Islam. Aegypt believed in the different roles of women that supplement male roles and did not, necessarily, seek equality of sexes.

Uleban (Lebanon): Uleban was forty-six when we met at her home, one that reflected a committed taste for the Orient with its furniture, musical instrument, decorations, and Islamic paintings. The house was meticulously clean and it directly mirrored the Islamic identity of its inhabitants. Uleban came to the U.S. five years ago, and although she had no children of her own, she had an extended family at the mosque and in the community. Before living in the U.S., Uleban taught in Saudi Arabia for many years and made a good living, but that was not a fulfilling dream of hers. Uleban was brought up in Lebanon, her homeland, but her Muslim parents were not religious. By the age of nineteen, she decided that she wanted to commit her life to social service. She considered becoming a nun thinking that only nuns could commit their lives to social services. Then

found out that she could study Islamic Law (Sharia) and keep her religion. She started attending lessons on Islam and after a year, decided to change from a modern young woman, to one who chose wearing the hijab. That was a big disappointment to her parents, especially to her mother who assumed that no one would marry her daughter any more because she wore hijab. She later had to leave Lebanon and study Islamic Sharia in Syria because there was a special Islamic theological college in Damascus. After getting her diploma from Syria, Uleban was hired to teach in girls' schools in Riyadh, Saudi Arabia, where she taught hundreds of girls every year for eleven years. She "made enough money to live in the U.S. ... now she worked for life hereafter." Uleban dedicated all her time to service and she stayed busy working for Allah with the dedication of spreading Islam to the West.

Uleban's marriage was also arranged. Her husband was in the U.S. when he asked his sister who lived in Saudi Arabia to search and arrange for his marriage. It was interesting to known that the husband decided to marry Uleban before he saw her picture even. He told her on the phone that he liked her soul, and that was the important thing he was looking for. When I met Uleban, she told me that her husband supported all her activities as long as she did all her duties at home. Uleban started praying with two female convicts, and she had at least twelve by the time I interviewed her. She won a certificate of excellence from the Department of Corrections and I was impressed with her achievements and encouragement to all convicts. During Ramadan, Uleban prepared daily food for hundreds of people in the mosque. She engaged fully in women's activities in the mosque. She became an extremely magnetic and charismatic person in the Islamic community. She possessed a particular gift for speaking about Islam and the social implications of the religion. She hoped to buy a van to help Muslim women's transportation, and her husband gave her one believing in her objectives. Uleban always sought contributions to the

74

community and emphasized her commitment to service. In her amusing way of expressing religions, Uleban "sought permanent residency in heaven and was not concerned about permanent residency in the U.S."

"The hijab is me ... a means to express my loyalty to God... He asked me [to wear it] and I acted" was Uleban's emphatic response to my question about hijab. Uleban felt that she had all the freedom she needed, that American "was a card for her mission" and that her dream was to build a bigger house with entertainment rooms of billiard, swimming, and working-out machines to be used by Muslim women. Uleban opened her home every week for a breakfast to everyone who wished to visit and for those who had questions about Islam. Uleban was a woman on a mission, devoted, sincere, and as she described herself as a woman, "with no boundaries."

Niran (Iran): Niran was a sweet and funny lady in her late forties. She was married to an American engineer and had two daughters. She had been in the U.S. for twenty-seven years. Due to the Revolution in Iran, Niran decided to join her brother who was living in the U.S., and then enrolled as a college student to qualify for legal residency. Niran was born to a faithful Muslim family and she had been taught to pray regularly and to fast in Ramadan. However, being Persian, Niran could not understand the Quran (written in Arabic) and her grandmother kept on insisting that any Muslim who wants to be close to Allah had to learn Allah's word (Arabic) and memorize the Quran. Failing to do that, Niran never felt that she understood the Quran, but she practiced all the rituals that her family practiced.

For the last twenty-seven years in the U.S., Niran had been trying to be accepted as an American. Niran met her husband at college in the U.S., and when they decided to get married he converted to Islam. Niran had to wait for her father's permission for marriage. Niran always felt that she needed God and could not live without religion. So, when the family moved to Oklahoma,

Niran started visiting churches and mosques, and decided that being a Christian is a "big deal to her." So, she converted to Christianity and asked her husband to convert. Niran attended church regularly, she believed that Islam is good for the people who understood it, and she felt offended if anyone tried to talk negatively about Islam at the time we met.

Before coming to the U.S., Niran "was not religious" but in the U.S. she thought that religion could help teach her daughters some morals. Niran felt angry with her neighbors who looked at her as an Iranian, an alien, and a Muslim. She felt angry with her in-laws who always called her 'brown' and who never accepted her, and she felt angry with her husband who, up to the time of the interview, still had prejudices against her. Fitting in America was a struggle, and she believed that she should have prepared herself more before arriving, like trying to change her accent and specializing in a field that society needed to help her fit in. Niran did not believe in the veil "it is a prison" and Niran wanted to be free to laugh and to show her face. More of the interview is in Appendix D as a sample of the interviews conducted.

Rindia (India): Rindia was a beautiful young lady who was very friendly and sweet. Rindia was twenty-seven years old, and was a mother of three: two sons and a daughter ranging from five to three years old. The first time we met at her home, I noticed that the choice of furniture, pictures, and few ornaments in the living room reflected Islam and had nothing to do with India. On the walls there were Quranic verses and pictures from Mecca. I could not see anything in the rooms that reminded of India, not even Rindia dress. Rindia was dressed comfortably in a long dress with long sleeves and was wearing a hijab that covered her head. Rindia had been living in the U.S. for five years. Before she got married, Rindia was a flight attendant and never thought that she would live in America. She described herself as "carefree" spirit, but not any more. It was interesting to know that Rindia was born a Christian, and then converted

to Islam to marry her husband following the Islamic traditions. Her husband joined us in the interview, and from time to time, he provided his points of view on the questions. Rindia chose the hijab to "tell people around [her] and to remind [her] that she is proud to be a Muslim. Without the hijab, [she] could be anybody. Rindia favored socializing with Muslim friends and had many Christian ones. Rindia loved to shop, "like therapy to her," and her husband emphasized his principle of not using credit cards. Rindia enjoyed the highways, the malls, and more shopping, things she never had in India.

Rindia was an active member of the women's circle in the mosque who volunteered to write articles on Muslim women to be shared in the circle. She enjoyed the support of the women and was pleased with her growth in the faith. Her challenges were learning directions, fitting in the community, avoiding men hugging her, and socializing with women alone in the mosque. When I met her, she was at a stage where she met all her challenges and accepted socializing with women alone. She believed that she grew stronger in Islam and that both she and her husband were more religious in the U.S. than they ever were in India.

Mcyprus (Cyprus): Mcyprus was in forty-five years old with a serious personality that reflected much self-control. She was a certified nurse who studied in American colleges in Cyprus, Lebanon, and in Turkey. Mcyprus was the mother of two college students and was married to an engineer. She came to the United States with her husband twenty-three years ago. Before marriage Mcyprus had a good job as a nurse in Nicosia, but after marriage she decided not to work in the U.S., but to be the traditional stay-in mother for her children. She had a brother who was a professor in Cyprus and she visited her homeland every summer with her family.

Mcyprus volunteered in schools, kept her house meticulously clean and was interested in gardening. Politics did not mean

much to her. Mcyprus was responsible for everything at home "even with related business and socializing dinners." As a Muslim in Cyprus, Mcyprus had to leave for Turkey to get higher education. She kept the religious practices and believed in the Quran, but not in the rituals that "look so fake and unnecessary because they were put by the people and they were primitive." She prayed at any time she needed to, not necessarily the five times a day commanded by the faith. Mcyprus' challenges in the new environment were being accepted in a "dominant Christian society." She had to learn new things like driving, using computers, and adjusting to American English. She made friends with American Christians, Buddhists, and even Hindus. Yet, she chose not to socialize with Muslims except those who were family members or friends from her country. She did not want to deal with Muslim women and felt "aggravated" for them because of the man's dominance over all of them. She saw things differently and "did not have the patience to be an activist among them." Mcyprus appreciated the laws in the United States and the freedoms that were for its citizens.

On the subject of veil, Mcyprus "did not believe that it was the rule of Islam." From the Quran, Mcyprus read about covering modestly, but there was nothing like imposing veiling on women. She believed that veiling was "a demand of a background society, not an Islamic one, and that women being so submissive, was aggravating. Women have no choice, because they are under the cruelty of men." Mcyprus got irritated when she saw women covering as if they were saying "We are covered; we are Muslims; we are safe."

Mcyprus believed that the majority of Muslim women from Arab "give the impression that women are needy people of their husbands to take care of everything." In her country, women are like men: they are in the workforce, university, and they both wear the "pants". Cyprus used to be a British colony, so even marriages are civil, no polygamy. To her, Muslim women can have hope if their men get educated.

Findings

[handwritten note: traditional, educated, difficulties assimilating]

Sjordan (Jordan): Sjordan was twenty-eight years old, taught Arabic at a community college and had been in the United States for five years. Sjordan's husband taught sciences at a community college and she had a three-year-old son. Sjordan had a Bachelor's Degree in English from Petra University. Her brothers and sisters were all educated. Her life in Tulsa is limited to her work and family. She volunteered at the mosque and was a member of the women's circle there. Sjordan wore the Islamic dress and felt comfortable. She missed her family, culture, and friends.

Sjordan's integration was not very difficult because she knew the language, was supported by her husband, and knew how to drive before she came. Her challenges were not knowing how people in America think and she felt that she and her family "are not total strangers, but not as equal as [Americans] are." Her major challenges were how to seek doctors and lawyers, how to fill out insurances and taxes, how to understand the system, how to prepare for interviews, and how to find good schools.

Sjordan kept the rituals and all the Islamic practices. The mosque and the circle of women answered many of her concerns, and the support of other Muslim women there was a major role in her new life. She described how "Muslims are a minority and usually minorities come together." She found support from people in the mosque for all social needs. Sjordan was impressed by the laws in the United States and the opportunities the country presented. Sjordan kept a website on cooking and she read much of her time.

As for the Islamic traditions that she followed, Sjordan emphasized that rituals she followed were "from Islam, we keep them all. In public schools on Eids (feasts) we keep them. We are wearing the hijab; nothing will change even if we are in the United States." Sjordan declared that she was more committed to Islam in the U.S. than before because she sensed a need to "show the kids" the value of her Islamic practices.

Sjordan had strict convictions about the veil that she

regarded as "an order from God," and what she learned about feminism in the United States made her believe that American women "struggle to compete with me," while in Islam there are "laws, rules, how women are treated." The right to work from her Islamic feminist point of view must be secondary to a wife's obligation where "husbands are priority." She was against the idea of women being totally on their own and was comfortable that Muslim women had "limits that protect women." Sjordan was excited with the possibilities, the technology, and the promising life in the United States as long as these do not affect her religious and social principles. Appendix E is the first interview with Sjordan as a sample of the interviews conducted.

Document Analysis: Emergent Themes

The interviews and written protocols, which the ten Muslim/Arab participants have provided, gave me the opportunity to identify certain patterns and themes that appear frequently. Document analysis simply means making sense and meaning out of the data I collected. I had a choice to either analyze each biography at a time or organize document analysis around themes that I found in common among the participants. I chose the later to reach a deeper and more applicable meaning. I found it important to briefly give descriptions on every participant as backgrounds to the themes. When I started studying the data I thought that it was hard for me to compare or to study different women from different age groups and different countries, but the more I looked at their interviews, the more I saw similarities among the ten Muslim/Arab participants. From the overwhelming data that I collected, I found interest in common issues on gender and class, traditions, modernity, religion, alienation, veil, gender roles, arranged marriages, and voices in Islamic feminism.

Gender, Class, & Adaptation. A couple of themes that may go along with one another are gender and class. The ten participants were women from an Arabic/Islamic culture where women are

Findings

[handwritten: more education - less intimidation - easier assimilation?]

not supposed to earn or to share in the income of the house. Syra's parents made sure that all their girls knew how to sew, cook, and take care of the house, while Suae's made sure that all their girls are as highly educated as their men were. When Ziraq wished to leave school at the age of thirteen, her parents did not mind her decision since they were convinced that her education was not going to get her anywhere. Ziraq's parents believed that only marriage can be a good start for her and for her family. Such decisions mirrored how social class and levels of education are dependent on gender. With a number of participants, gender and class were positive issues in their lives and literacy as with the cases of Mcyprus, Niran, and Uleban whose families secured education and high expectations from their daughters. Mcyprus studied in Cyprus, Lebanon, and Turkey before she got married and moved to the U.S. Niran's parents sent her to the U.S. to study; Uleban left to Syria and Saudi Arabia to study theology. Those participants' social class helped them integrate more easily as they were less intimidated in the new environment being in upper class made adaptation easier, which proves that there is a strong inter-relationship between class and acculturation. Mcyprus felt that the U.S. was her true homeland and she never considered going back to Cyprus except for her annual summer vacation, so did Niran and Uleban who integrated more smoothly due to their education.

Gender affects how people socialize, are treated and judged by others and by themselves. Prieto (1992) confirmed that "when socially constructed ideas about gender conform to a totally different environment (as the case with migration), migrant men and women may resist, change, or adapt their beliefs to the new situation" (p. 186). When my participants found themselves in a new culture and encountered new aspects of freedom and feminist rights, they adapted very differently. Those who came from educated and well-to-do families found new meanings for their being women in a democratic society, while others who were less educated decided to follow what they

are taught whether in the mosque or by their husbands. Thus, the participants' experiences differed on gender due to their level of adaptation, education and class: yet another proof that the upper class and the educated, from any country, are better equipped to adapt easier and to succeed faster in their new environment.

On the theme of adaptation, many immigrant Muslims who find themselves in a society, in which values and customs are sharply different from those in their native cultures, face significant problems: they either drift away from their faith and integrate in the American society, as was the case with Niran, Dturk, and Mcyprus, or commit to new Muslim communities to affirm their traditional identities as with Uleban, Sjordan, Syra, and Aegypt. Few of my participants came to the U.S. in search of a radical change; the majority followed their husbands. However, in relation to their lives as Muslim women, they all took on new roles and had more independence and freedom. Such changes differ by family situation, reason for migration, and from one woman to the other, but all noted differences to a certain extent. Even Ziraq, who knew little English and who could not drive, took new responsibilities of helping her husband in the store and felt that her husband started listening to her more "not [as] in Iraq" as she kept telling. New responsibilities for women included shopping, taking the children to school, dealing with medical establishments, and sometimes taking a job to help with the family finances. Sjordan started teaching Arabic to help with the family, Dturk took a full-time job, and Syra worked at home altering clothes. The activities women did in a new environment helped them all to be involved in the community and facilitated their settlement. Mcyprus, Rindia, Niran, Dturk, and Aegypt volunteered in their children's schools to figure out how the educational system worked and how they could better understand it.

Needing to do various chores for the family involved learning new skills such as driving, improving communication skills, and learning to read. The most challenging skill was to overcome

the fear and intimidation all the participants felt. Niran was ever fearful of "neighbors discriminating against her [because] … of her accent … and searched for acceptance." Every school day was a challenge to Syra as she feared that a policeperson might stop her for any reason and she never knew what to do due to her poor language, so she "prayed and asked for Allah's guidance." Syra chose a Muslim school for her children because she feared not being able to understand what was needed in an American school and she wanted to check on her children's daily assignments "I feared attending a parent conference in an American school."

None of the participants assimilated totally in the American environment. The idea of a melting pot proved to be unrealistic since the immigrant women came to a new environment with their own culture, faith, and objectives. However, they all integrated on different levels following the metaphor of the "salad bowl" where immigrants remained culturally plural and ethnically unique. The levels of adaptation and integration in a new physical environment and social contexts proved easier for participants who were familiar with the language and the laws and whose social class prepared them better in facing the cultural shock. Rhinesmith (1985) described culture shock "as a behavioral, emotional, mental, and physical response to the unfamiliar [which] is derived from both the challenge of new cultural surroundings and loss of a familiar environment [including] the loss of family… ability to communicate linguistically… understanding what is expected, and perform[ing] at levels of excellence" (p. 148). For proper adaptation and to ease the cultural shock, the participants searched for support from other immigrants who were in the U.S. before, and many depended on their faith and the cultural retention they found in mosques.

Keeping Traditions, Fearing Modernity & Maintaining Arabic. Many of my participants did not oppose the West, but they did not wish to live its modern ways. They resorted to traditions

that help them choose what was harmonious in their society, community, and faith. However, during hard times, like wars and immigration, alienation from modernity appears to increase as modernity advances, especially for those who try to reject the present. This may explain why many Muslim/Arab women, some in my study, started committing to Islam and to hijab after residing in the U.S., and not before. Modernity, to them, is not what they wear and how they look, but it is a conscientious change in selecting what fits best to their culture and life, echoing Guenon's Traditionalism that "what mattered was not the religion of the future but the tradition of the past" (Sedgwick, 2004, p. 53). If modernity is the answer for freedom, then Sjordan fears such aspects and did not want to consider them for herself:

> Here women are more independent even if that will affect their homes and family. They want to be independent from a younger age, which lead to living alone, go to parties and do whatever they want. We have limits and this protects women. People protect them from an early age. It did not affect and change my view of how women should be treated and my religion gives women all rights, complete from other sides without the need of modern ways.

Dturk, who lived alone with two daughters and agreed to her husband working in Iraq, feared a modern culture that allowed "young girls to live alone … it scared me that at such an early age, a girl can decide to be on her own. I like it here that parents' responsibilities cease at a certain age, while in Turkey one can stay home with parents forever, but too soon at an early age is scary."

All the participants, kept the five commandments of Islam – declaration of the faith, prayers, tithes, fasting, and the pilgrimage to Mecca – but on different levels. One major factor of keeping traditions was to know Arabic. Aegypt "dutifully

takes her children to the mosque every week to keep in touch with the language and traditions." When I asked Syra why she sacrificed much money to send her children to an Islamic school, she emphasized that

The Islamic [school] is very expensive, $180/month, and $170 for the second child. If you ask me why I sacrifice that much money every month, I can say that because I wanted them to learn Arabic, then they can understand the language when we visit back home and they can understand and read the Quran. I tried to teach them Arabic at home, but I was not successful. So I sacrificed to keep the language.

Ziraq never wanted her daughter to speak English words even at the age of three, but only encouraged her to speak Arabic. Ziraq knew that her daughter would learn English anyways in the U.S., but she had a duty to teach her Arabic to know how to read God's words in the Quran. Ziraq expressed her fear that English language might restrict her expressions, while her language would allow her to express emotions and ideas which would always be difficult to express in a foreign language.

Niran converted to Christianity, not so much that she was convinced more by the Christian faith than in the Islamic one, but because she never understood Arabic and consequently, could not understand the Quran: "I never condemned Islam, I still respect it, it is a good religion for the right people, but I did not understand it. I tried to read the Quran in different languages; it was not easy for me to understand." Since the Quran is in Arabic, followers of Islam believe that, no matter what language they use, they must pray in Allah's language: Arabic and that no translation will ever do justice to the original text. Although not all the participants in the study were Arabs, still all wished they knew Arabic to understand the faith more.

Spiritual Growth, Spiritual Support: Why is Religion Important? A major theme among the women I studied was the importance of religion in their lives. Both Syra and Sjordan learned more about

the Arabic language from their parents, Muslims and Arabs. Syra related how she "learned to recite the Holy Quran by the age of three and used to pray with her mother five times a day. That was all before she went to school." Sjordan also recited the Quran all the time and learned the rituals from the practices of her parents and grandparents. So, why is religion important to Muslim women immigrants?

All the ten participants in the study showed commitment to their religions in different ways and on different levels. While three participants showed complete involvement in the mosque, four were committed occasionally, three do not believe in the ritual of mosques, and one converted to Christianity because she could not live without a religion. Not being able to generalize why my participants choose certain attributes that they feel comfortable with the faith, I had to work individually on what it meant to them to be religious.

Suae trusted religion to guide her in all aspects "I am not so religious, but what religion I do know, I understand. I'm proud of being a Muslim female, and I'm challenged with learning to cope with the religion and tradition over here in the States." Uleban trusted religion to guide her life. Even at an early age, Uleban left her parents to study theology in another country, contrary to what they wished her to be. Uleban felt that she was "on a mission to convert people to Islam," and that her stay in the United States "was an opportunity with limitless possibilities for the Islamic faith." Uleban could not envision her life without religion as she was totally immersed in her belief of winning people to Islam. Syra felt it was her duty to show her husband the 'right' way to religion, and after she wore the hijab and kept praying five days a week, her husband started to fast and to pray. "Praying is a duty, on Friday my sons go with dad to the mosque, they see me praying, now it is my duty to make them all pray and do all the commandments." Syra learned more about religion in the States as she was encouraged by Muslim friends to learn more. Sjordan felt that she was "here [U.S.] more committed,

learning about Islam, etc. We struggle here to keep the faith, for the kids, which means that we should commit to praying on time, and that my son should see me. Same with the fasting, so to show the kids and it will encourage them... how we celebrate feasts similar to how Christians celebrate Christmas." Rindia admitted that she started being involved in Islam when she came to the U.S. Rindia converted from Christianity to marry her Muslim husband and both were involved in the mosque. Rindia started favoring "Muslim friends because I felt I have more in common with them and I can be more of myself with them without stress."

Thus, adaptation to a new environment causes immigrants, especially women, stress, fear, isolation, and tension in their lives, and many resort to more social and religious support. Many participants became more religious in the host country than they were in their homeland. Rindia, Sjordan, Uleban, and Syra became involved in the mosque and decided to commit to wearing the hijab in the United States: a decision that eased their tension, gave them a sense of identity and security. Religion to them, as Mernissi (1987) described it, is "the comforting cradle of a cosmic ideology" (p. 13). The involvement brings them comfort, allows them to practice their values and to appreciate what their culture teaches versus what they witness in a foreign and morally overwhelming environment. Ahmed (1992) described how affiliation with Islam brought comfort and a sense of community. Men's support and encouragement added to the comfort (p. 223).

Based on his work with immigrants from India and Pakistan, Williams (1988) concluded that:

> Immigrants are religious—by all counts more religious than they were before they left home—because religion is one of the important identity markers that helps preserve individual self-awareness and cohesion in a group.... In the United States, religion is the

social category with clearest meaning and acceptance in the host society, so that emphasis on religious affiliation and identity is one of the strategies that allow the immigrant to maintain self-identity while simultaneously acquiring community acceptance (p. 29).

The majority of my participants' choices supported Williams' conclusion; however, there were exceptions. Mcyprus "believed and tried to follow the Quran, you have to go with the book. All the rituals are nonsense; I don't do them. They look so fake and unnecessary most of the rituals are put by the people". She said that she prayed, paid tithes, and fasted the month of Ramadan because it "gives her something deep spiritually to re-examine herself." Mcyprus was very "aggravated" with the ways mosques teach women to be submissive. Mcyprus stated that "children do not have religious lessons at home, but by example, the life that we live. My children have their own Quran if they wish to have reference from it. It is a personal thing. If they wish they can do it." Dturk shared similar sentiments towards religion and the mosque and Niran decided that she could never please her grandmother and learn Arabic so as "not to miss on God's language and message" and that made her decide to choose another religion because she could not "live satisfied and fulfilled without a religion."

Feeling Inadequate: Alienation with Acculturation. One major objective of the study was to understand how Muslim/Arab women feel as they attempt to be a part of the new culture in the process of acculturation. The new language, laws, and customs are sufficient to keep many women unsure of their skills and abilities which lead to "downward social and occupational mobility" (p. 21). Women immigrants, like men, feel alienation and tension in the process of acculturation and as a result of losing family ties, the familiar, the social and religious affiliations, and acceptance. Niran stayed twenty years trying to be accepted

in a community that kept judging her due to her accent, color, and country, reminding her "of being, not only an alien, but an Iranian." Her feeling of rejection and her accent discouraged her from pursuing a teaching job in mathematics. Niran described her challenges and confusion in her identity since she had lived almost thirty years in the U.S. but she still felt inadequate. Suleiman (1999) expressed how "among the most important issues with which Arabs in America have had to wrestle is the definition of who they are, their sense of identity as a people, especially as they encountered and continue to encounter bias and discrimination in their new homeland" (p. 11). Niran felt that her husband after decades of marriage still "discriminated against her" and that her in-laws called her "brown."

Syra wished to work as a saleswoman at the mall. Her feeling of inadequacy and the rules and laws that she never knew before, obligated her not to even try. Her insufficient knowledge of how to apply for a job, what to expect in an interview, what to ask for, and who to reference her were all obstacles that discouraged her. Feeling inadequate to search for a job, Syra chose the other extreme and resorted to more traditional life by becoming active in the circle of Muslim women in the mosque. Ironically enough, Syra felt adequate in a church where she was taking language courses:

> I was always afraid that someone would laugh at me if I made mistakes. My husband did that once in front of his friend when I made a mistake in English. I stopped speaking English for a long time. Now I take English courses at a church where they taught me, not only the language, but what to do when a policeman stops me, what to do if I lose my purse, how to read a ticket, what to do with bank accounts, and who to call for theft report. The more I knew, the more I felt as an American.

Ziraq felt inadequate and limited to her home or to her husband's business where she helped whenever necessary. After three years of residing in the U.S., her "language improved, but not the rest of the difficulties". When I asked Ziraq if she wished to consider schooling, she faithfully said "you know sister, I dream of that [schooling], but I do not know how to do it. I am willing and I have the time and determination, but I do not know where to start, how to apply, what to prepare, or what to do. May be Allah will send someone to help me know." Thus, immigrant Muslim/Arab women felt inadequate due to their languages, and accents; they also felt discriminated against and judged according to their life-style and traditions.

Behind the Veil/Hijab: History, Identity, & Rejection. The veil holds differing meanings depending on to whom one speaks, when, where, and why. If one speaks about veiling to a Muslim woman in Afghanistan during national unrest, it is different from speaking to a Muslim woman in France after passing laws to restrict veiling. While both may choose veiling, the reasons and times are quite critical. However, in general, veiling is viewed as a means of male domination of Muslim women but it is also a divine order to protect women. The immigrant Muslim/Arab participants in the study reflected the many meanings they held for donning the veil and for wearing hijab, and these meanings can be grouped in three categories: Participants who chose to wear a veil and hijab in the U.S., not before (Syra, Rindia), participants who chose not to change their habits of wearing them (Suae, Ziraq, Aegypt, Uleban; Sjordan), and participants who considered wearing a veil or a hijab a symbol of oppression and backwardness (Niran, Mcyprus, Dturk). So, what is behind the veil? Is it history, identity, both, or far more? Participants' views on veiling varied from modesty to social significance to historical tradition to the importance of identify to a symbol of rejection to aspects of modernity to a political statement.

The issue of the veil and the hijab has been debated in

literature, history, and every society ranging from Islamic, to Arabic, to Western. Both words, veil and hijab, may be used as head-cover and are meant to promote privacy for females and to prohibit the intermingling of sexes. The veil and hijab are supposed to ensure modesty, decency, chastity and above all, respect and worship. The way the word veil is used in English is to conceal truth, or it can protect truth; in Arabic it is used in the sense of protecting purity. Thus, the veil becomes a symbol of purity that intends to send a message to the observer about the women in veil. For example, when a woman rejects hijab she is, indirectly, rejecting masculine authority or traditional authority which is imposed by men. It is the men who say that the hijab protects a woman's purity. It is the outsider who judges the status of the women in a hijab. When the woman wears the hijab, the observer says she is pure. The veil or hijab then has a figurative significance that is both cultural and social. Ziraq stated that "she felt naked without the veil … modesty is a requirement…. Physical attractions are distractions ….We hear stories of rape due to attractions from wearing shorts, mini skirts, and bathing suits." Suae emphasized that she was "not flexible with the hair cover, [she] covers everyday when she leaves home… it is [her] identity as a Muslim female … [she] believes in it… All the females in [her] family cover their heads…. [she] sees herself wearing the head cover all through [her] life."

In many Islamic societies, young girls are permitted not to wear a head scarf before getting married, but once they get married, they are encouraged to hide their physical attractions. Rindia and Syra felt a need and pressure to cover after being married and Syra stated that she "will not ask her daughter to wear a head cover, but she will after marriage seeing that I did that myself." Both participants from Syria and India chose to wear the hijab in America (they did not wear it back in their homelands) because they wished to send a message of identity and pride. Syria feels "safe and secure … as she is: a Muslim with a culture." Rindia emphasized that "the hijab was [her] choice …

without the hijab [she] could be anybody ... with the hijab [she was] proud to be a Muslim."

Aegypt started wearing a veil after the catastrophic loss to Israel in the 1967 Six-Day War, as did many Egyptian and Arab women as a reaction against the failure of secularism and as a reaffirmation of national identity and rejection of values and styles assumed to be western. Majid (2002) described how in countries where the veil was not mandated, "many women chose it both as a reaction to a failed bourgeois nationalist program ... and as a part of the mainstream, middle-class rejection of the secular ideologies that have dominated public life" (p. 117). Such failures promoted a push to return to Islamic laws which had been abandoned. Modernization was seen as negative, a phenomenon which encourages people to reject religion and traditions. In Medical School, Aegypt felt that she wanted, like many other college women at that time, to voice her disappointments in following the West. It is interesting to realize that unveiling was common in mid twentieth century, but re-veiling became popular when oil was discovered and nationalism failed. More young women took back veiling in Saudi Arabia and in Egypt, as they are doing now in Iraq, Jordan, Lebanon and other Arab/Muslim countries.

Like Aegypt, Sjordan started wearing the hijab in her first year of college. She felt that wearing the hijab was a message for the men "not to harass her or think that she was available. It was a comfort for my parents as well." Uleban, Syra, Aegypt, and Rindia all agreed that the hijab or the head cover is a demand from Allah. Uleban stated that the "hijab is me ... a means to express my loyalty to God"; Rindia assured that "without the hijab, I can be anybody... with it, I am obedient to Allah"; Sjordan stated that "the veil is an order from God." To Syra "the hijab provides psychological comfort ... [she] feels safe and secure in a veil It hides my tension." All the participants in the study showed that they do not find value in modern dress but in keeping conservative family values.

Whether it is a head cover or a body cover, the participants who choose to dress modestly agreed with Moghadam (1993) that European and American women, with their revealing clothes, have become mere sex objects; and their freedom to behave like men not only goes against nature but robs them of the protection and even respect of men" (p. 141). That may explain why university and professional women are adopting Islamic dress – women who daily venture onto coeducational campuses and into sexually integrated work places on crowded public transport in cities. At the same time it declares women's presence in public space to be in no way a challenge to or a violation of the Islamic sociocultural ethic (pp. 223-224). For women wishing to pursue professional and public social lives, wearing hijab allows freer movement outside the confines of the home.

On the other hand, Niran, Mcyprus, and Dturk believed that veiling is not a commandment from Allah and that it is a creation of men to subordinate their women. Niran "did not like to cover [her] face and body. [She] did not want to show a sad face and never smile. In my country, you hide your smiles; Islam is a religion that is not humane to me." Mcyprus believed that veiling put women more "under the cruelty of men ... women have no choice... and veiling makes them more dependent on men." Dturk stated that she "does not believe in a veil. If I see a woman with a veil, I do not like it ... the veil tells me that the woman has no voice and is no presence."

"Why Can't Muslim/Arab Women Be Like Us?": Gender Roles, not Equality. Even when Western women do not ask this question, it seems implied in their attitude and judgment of Muslim/Arab women. It is difficult to explain to a Euro-American feminist that cultural traditions are rooted in the lives of Muslim women, and that the majority of them do not wish to be individualistic, totally liberated, and aggressively demanding equality in rights and careers. Usually Muslim women, regardless of their levels of

education, class, countries of origins, and levels of integration when in foreign lands, acknowledge their primary role as mothers and wives and they trust arranged marriages that rely on collective advice of families. Sabbagh (1996) stated that "there are one billion Muslims in the world today and the Arab-Islamic world alone exceeds two hundred million people living in 22 Arab countries. Each country interprets women's rights under Islam somewhat differently, and within each country social class is a determining factor in the way in which women's personal rights are treated" (pp. xv-xvi). However, when it comes to their roles and responsibilities towards their families, all the participants in the study have deep traditional values of the roles of women in Islam.

Sjordan, a graduate student and a college instructor, expressed how she believed in her role as a Muslim woman: "Islam has laws, rules, how women are treated, and that they have the right to work and study with limits, because their husbands and families are priority." Niran decided not to work since her family, "needed her family the most … found joy and acceptance in my family… what to prepare for them was my only objective of the day … being home when my kids come from school was giving them security, love, and an important role of acceptance."

Mcyprus, although a certified nurse, never worked in the U.S. believing that she did not wish to be like many American mothers who had to work but lose touch with their families. Mcyprus stated that she was

> a stay-at-home mom. Despite my children being grown up and left to college, I still have a tremendous amount of work: housework, volunteering, reading, and gardening… I am in contact with my kids' daily needs…are more emotional and advisory things. I even have responsibilities related to my husband's business and often prepare socializing dinners.

Rindia, a former airline hostess, found much satisfaction in staying home with her three children. Although she wished to earn money to help the family more, Rindia and her husband decided that they were better off living on a limited one paycheck rather than shifting focus from building a "true Muslim family." The others participants shared similar feelings towards the importance of families trusting that "the family in Islam [is] the modern-day corporation, [that] assigned different roles" (Sabbagh, 1996, p. xiv).

Aegypt insisted that Muslim women contribute to the Islamic community's interest, not to their individualistic ones. Consequently, there are roles, not necessarily equal ones, but complementary ones. "I believe in women's roles. Twenty years ago, I would have said, "Yes, we need equality. Those men are taking everything from us." Now, being 46 years old, with five kids, it is all about roles in life."

Uleban affirmed that gender roles were assigned by the Muslim society to protect and to involve all. Although Uleban did not have children, she still believed that her role as a wife was to keep the house, prepare the food, and manage the household, after which she could volunteer in mosques or in converting female convicts to Islam. Her devotion was primarily to Islam, to her husband, to the Islamic community, and to Islamic mission believing that "a woman's role is to build a Muslim community and to raise good Muslim children."

Arranged Marriages: The Community's Interests versus the Individual's. The majority of participants, regardless of their levels of education, class, countries of origins, and levels of integration when in foreign lands, are unwilling to commit to marriages without the consent of their parents and without the collective advice of both families involved. The participants in the study acknowledged their trust in arranged marriages and gave reasons that were rooted in their conservative culture and in the social communal interests of the individuals. A participant stated that

arranged marriages proved to be more successful and lasting than the romantic ones. However, other reasons were as important. Keeping the community's interest on top of all, Barakat (1993), a Syrian Arab sociologist at Georgetown University, described how the family in Islam is the central socio-economic unit of society: "The traditional Arab family constitutes an economic and social unit in the sense that all members cooperate to secure its livelihood and improve its standing in the community." (p. 97). When parents arrange marriages on behalf of their young ones, the marriage is not to be built on 'blind love' or on physical attractions, but on compatibility. A marriage is not a contract between two individuals who decided to get married, but is a familial or communal rather than an individual affair:

Officially a [marriage] has been perceived as a mechanism of reproduction, human survival, reinforcement of family ties and interests, perpetuation of private property through inheritance, socialization, and achievements of other goals that transcend the happiness of the individual to guarantee community interest. (Barakat, 1993, p. 107).

Suae described problems that face women in the Arabian Gulf, such as in Qatar, Saudi Arabia, Kuwait, Oman, Bahrain, and the United Arab Emirates. She detailed how women make decisions collectively and are protected by the men in the family as families try to find the best way to deal with things. Families also deal with marriages and divorces. Suae presented why she trusted arranged marriages and why, upon her return to the United Arab Emirates, she was going to trust her family to find her a husband, establish a family, and then pursue the possibility of a doctorate degree in the U.S.:

I do trust arranged marriages. My parents had an arranged marriage and my friends had arranged marriages. The two families that arrange the marriage, they understand and know each other. The spouses both trust their families, and know that their mate is well-chosen. For example, one of my friends, she saw her husband for the first time on the wedding night. They

were both nervous, but they were patient with each other. I appreciate that very much, because they both understood what each other was going through and weren't selfish. You keep thinking about the other person, not just yourself. Behavior and manners come first, then being selfish and looking at your own needs and wants. This is pressure, also, and stressful, but women in my country have learned how to do it, and they are coping with it very well.

Syra described how her aunt escorted her to the U.S. to meet her husband for the first time in her life. Trusting an arranged marriage, Syra's family and her husband's family met in Syria and signed the contract: "My husband could not get to Syria … I got a visa to New York to visit my sister … met each other, and later signed a marriage contract in a mosque."

Although Niran's husband was an American she met in college, she had to get her brother's approval and her father's consent. Her marriage was not totally arranged, but she did the best she could to involve the men in the family. Niran asked her husband to convert to Islam before the marriage and her parents agreed to the marriage. However, the only thing needed was "to ask my father's permission and that had to be in writing because we wanted to follow the Islamic rule for marriage. We had to do all these rules, my husband had to convert to Islam and we had to have a marriage certificate signed by a Muslim clergyman." All the other participants, Uleban, Mcyprus, Dturk, Rindia, and Aegypt accepted arranged marriages. So, why were arranged marriages common among all the participants? Simply because arranged marriages are protected by families and due to the majority of Islamic states being "ill-equipped to provide the same amenities to the individual as in Western countries" (Sabbagh, 1996, p. xv). In a patriarchal society where the family is the social unit, women find security and guarantees within the family, not outside it.

Avenues & Voices of Islamic Feminism: Dominant versus Alternative.

All the Muslim/Arab participants showed a certain level of belonging and of having a voice of feminism. Niran, Mcyprus, and Dturk described their voices liberated from the rituals and customs of Islam, they were agreeing with the dominant voice of feminism, which affiliated itself with the westernizing, secularizing tendencies of society. Such a voice promoted a feminism that assumed progress and modernism by Western style societies. Mcyprus stated that when immigrant Muslim/Arab women are open to change, their lives will be easier. If they do not accept the life, they will have a lot of trouble, but if they restrict themselves to rituals and traditions, they cannot survive on their own. They give the impression that women are needy people of their husbands to take care of everything Life in the U.S. … needs relearning especially technology and lifestyle…"

Following in the dominant voice of feminism, Mcyprus informed how "rituals are primitive, and is totally against women's submission to men and that and it says to modestly cover yourself, not to cover your body from head to toe. I believe it is a demand of a background society, not an Islamic one."

Niran felt comfortable converting to Christianity believing that progress and modernity waited for no one. Niran wanted to "enjoy the freedom of living; [she] did not want to be behind a cover." Niran sought "achievements with the abundance of opportunities of a modern society." Dturk was determined not to allow Islamic traditions to rule her in the United States, and even decided that she could keep the family on her own and allowed her husband to leave for Iraq. Deturk had a job, went to school, and took care of all the demands of the family without the need of her husband. She followed the dominant voice of feminism that promised advancement as individuals adapt to the Western life rather than follow the limiting traditions of Islam.

However, the majority of the Muslim/Arab participants voiced the alternative feminist voice in Islam: one that opposed to Western ways, searched for a way to articulate female subjectivity and affirmation within an Islamic discourse. Such a feminist

voice looks for the ability to fight Islam with Islam. Women are supposed to keep Islam and find avenues for their rights from within. Suae, Uleban, Aegypt (all on a graduate level from the United States) were voices that did not want to be liberated from Islam, but wanted to work for their transition in acquiring new rights from within the Quran and the Sharia. When I asked Aegypt about feminist rights, she responded:

> We should go to the book that came from God and see what we should do, because one day, we will face God. Whatever is in the book, whatever we can do to improve ourselves as Muslim women…of course, the book says we don't have to be ignorant…We have to be the best scholars, scientists…best of everything. We have to keep our soul, our spirit, our religion, and be the best. This world can accommodate everybody.

By educating Muslim women, the alternative voice of Islamic feminists seeks to find interpretations in the Sharia that are fair to women. Suae believed that feminist voices had to support other women and help them advance through Islamic traditions and beliefs. Suae described the alternative voice of feminism in the U.A.E.:

I know that women [in the U.A.E.] are very organized and they council each other and they have a women federation and they have established laws and are backed up by the government. Women [in U.A.E.] who are educated and in these positions, they reach out to women who are less fortunate…. They're developing, from good to better and they are maturing. We make decisions collectively. Women are protected by the family and we value family.

Uleban showed that a voice of Islamic feminism had to be found from within Islam and that the best Muslim women could do was to support other sisters in the faith. Uleban opened her home to Muslim sisters every week and discuss their concerns

from the holy books. To help them grow in understanding their rights in the faith, Uleban dedicated her time to serve sisters in Islam, notably on special occasions:

> During Ramadan, I prepared daily food for hundreds of people in the mosque. I engaged in all the women's activities in the mosque. I once wanted to buy a van to help Muslim women's transportation, and my husband bought me one. I visited women convicts who converted to Islam and I gave them presents....supporting my sisters in Islam is a feminist contribution.

The main objective of the alternative voice of Muslim feminists is not to liberate women from Islam but to acknowledge their rights from within the faith. More and more Muslim women, especially after the Iranian Feminist Movement, are getting more attracted to the alternative voice where they can keep their faith and traditions and at the same time find new avenues for feminists from within. Uleban, Suae, Djordan, and Aegypt reflect such a voice. While, on the opposite side is the dominant voice that encourages total separation from the patriarchal and conservative norms of Islam and seeks liberation for women in harmony with the Western feminism, as voiced by Mycyprus, Dturk, and Niran.

Conclusion

The focus of this chapter was on a fairly under-researched but critical element: Muslim/Arab women who immigrated to the United States at one time or another (since one of them has actually left the country) and their experiences as they struggle to attain life-goals in the United States. The ten participants came from different Islamic countries; what they shared with me reflected their views, practices, beliefs, and feelings of how they integrate in the American culture while trying to maintain their Muslim/Arab cultures.

Findings

5. Conclusions & Implications

The lives of Arab/Muslim women vary but all experience some difficulty entering American society. The participants and my knowledge of the lives of the participants in the past might inform the present so that present generations will not fall into the similar situations that create tension in their new culture. The interviews tried to explore the participants' past in Arabia or in Muslim countries and their experiences in America. My objective was to use past and present experiences to structure an educational curriculum that will ease integration. The objective is for future immigrant women to be able to organize their lives with greater ease in all aspects or relationships; marriages; participation in social, economical developments, and legal aspects that provide chances for positive views and smoother integration in the U.S.

Discussion

Immigration is never easy as immigrants have to adapt, assimilate, and acculturate on different levels that need coping mechanism causing tension, trauma, and life transitions. The immigrant Muslim/Arab women have to deal with risks and challenges common to other immigrants: language difficulties, raising children in a minority faith, adjusting to a non-collective society, and searching for spiritual and familial fulfillment. What

is common among them is the cultural tension they experienced as new immigrants, and many still experience this tension even after decades of living in the United States. However, their stories of resilient strength and empowerment contradicted societal stereotypes about Muslim/Arab women. Many of the participants demonstrated empowerment and a conscientious level of integration that is in harmony with their beliefs and aspirations. Many are successful socially and educationally in the U.S. They emphasized the importance of family, faith, gender roles, spousal support, collective bonds, and the importance of resilience to face the tensions they experience as immigrants. The participants showed different values for the veil, voice, arranged marriages, and integration. Bringing attention to the lives of my participants is a way of acknowledging value in their experiences and of highlighting the Muslim/Arab cultural, social, and educational aspects from feminist views. Thus, the study was designed to further the understanding of Muslim women who live in the United States and to lead eventually, perhaps, to an educational curriculum for new immigrants Muslim/Arab women that can ease their integration in the new culture.

The Findings Suggest

A Lack of Knowledge and Positive Attitude. The findings suggested that the women in the study had difficulty assimilating to American society because they felt that this society treats Muslims differently from other groups like the Catholics or Jews. Although almost all of the participants were American citizens (with the exception of Suae), many did not feel that they belonged even after decades of living in the U.S. Sjordan expressed how she felt Americans viewed her:

> No, I do not think that they (Americans) consider me one of them (an American). I feel that I am a stranger, kind of. Even if I want to think about it seriously, I have a permanent

residency, I have the rights, but we are looked at differently. We are not total strangers, but not as equal as they are.

Many felt that little was taught about Arabia or Islam in American curricula, and it was difficult for the participants to explain the diversity of the Muslim community in the United States and the Muslim countries in the world. Ziraq described how hurt she felt when people associated her with the war in Iraq and when they judged all Muslims to be trouble makers: "They [Americans] do not know us… they do not differentiate between Iraq and Afghanistan … to them, we are all Muslims." Thus, such experiences attributed to dis-assimilation, otherwise known as "negative assimilation" and cultural marginalization resulting from cultural exclusion. Most participants were unable to function fully in the United States because they did not know the language, lacked necessary education, and were unfamiliar with American customs. Syra was scared every day as she drove her children to school that a police officer might stop her for any reason, and she never knew what she would do. She wished to work as a saleswoman, but she did not know how to apply or where to get references. Fearing to be judged stereotypically, the majority of the participants focused on socializing with other Muslims, and sent their children to Muslim schools which kept them more excluded in the new society. The findings confirmed how centuries of strategic, commercial, and diplomatic contact between the governments and people, have not helped Arabs/Muslims and Americans cultivate an inventory of healthy knowledge about or positive attitudes towards each other. All the participants shared their fears of being accepted in the American society especially after September 11, and all agreed that Americans knew little about them.

Stresses of Acculturation, Resilience, & Growth. The study showed how Muslim/Arab women shared the stresses of acculturation and the aspirations in a new culture. Many struggled to affirm

the traditional values of their faith while at the same time saw the need to try to function in American society. The Muslim participants detailed their processes of migration and the loss of the familiar, coupled with the need to confront new situations. Ziraq missed having tea with her family members, and she mourned the loss of the opportunity for her child to grow up with cousins, aunts, grandparents, and neighbors. Aegypt missed the shared values, the solidarity of faith with her friends, and her ethnic food. Syra lost the warmth of her easy life back in Syria: such unhappiness about the minor things at times became so great that some of the immigrant participants who reported becoming "depressed and frustrated" in a new environment.

In addition, Muslim participants had to confront the fact that they had to replace what they were used to with changes. Hermansen (1991) described acculturation as a concern for Muslim immigrants: "[acculturation] is the process of confronting a new cultural context and worldview and having to choose where to adapt to aspects of the context or worldview in one's own life" (p. 189).

Other kinds of stresses that faced Muslim/Arab women were their concerns about how to raise their families in a liberal society, especially while raising their daughters. Syra described how she feared peer pressure on her daughter regarding dating, partying, drinking, and living on her own when she becomes of age. Dturk voiced similar fears for her daughters leaving home or even sleeping over with other friends: "It is scary to even think of my daughters living on their own." Identity became a major source of stress in the process of acculturation: how to keep a conservative identity while in the process of change.

The study explored how these female immigrants made decisions about cultural behaviors, ethnic socialization, religious practices, educational choices for themselves and their children, and their roles as Muslim women in a modern society. All the participants practiced selective acculturation, picking and choosing what behaviors to keep from their cultures and

what to refuse from the host or new culture. Those who joined the women's circle in the mosque shared ideas and whatever knowledge they knew with others, and the leaders were expected to inform about many aspects of life in America ranging from what doctor to consult, to what insurance to buy, to even what store had sales.

The participants described how their faith and beliefs "protected" and held them, providing comfort and helping them mourn losses and manage new challenges. Rindia felt much comfort and solidarity with the women in the mosque to the extent that she decided to wear the hijab to be one of them. Syra too needed the support that helped strengthen her resilience, and after hearing the Imam at the mosque preaching on the hijab, she decided to wear one also. All other participants, even Niran who converted to Christianity, described how their faith guided them and filled them with hope. Mcyprus, although not knowing Arabic to read the Quran, kept one close to her bed and gave each of her children a Quran to keep their faith to help them stand against hardship and challenges. In this study, spiritual growth emerged as a central aspect of resilience as the participants described a process of growth, both socially and religiously. These findings agree with other writers' observations that immigrating to American often sparks a spiritual "awakening" in many Muslims, offering them an opportunity to strengthen their faith, to build closer relationships with God, and to rediscover and redefine their personal, familial, collective, cultural, and spiritual identities in positive, empowering ways (Haddad, & Lumis, 1987; Haqu-Khan, 1997).

The participants felt strong and patient as they grew through trauma and adversity. Faced with the challenges of immigration and the critical attitudes by the new host culture, the participants created opportunities to keep their culture, language, and faith as they became aware of the need to be flexible in thinking and in actions. Sjordan described how many Muslim women who came to the U.S. without knowing much about the environment

went through stages of resistance, then self examination, and after time, progressed towards integration, first within their communities, then many moved within the American society.

Adjusting to the "ups and downs" of acculturation, the participants told of many stories where they were challenged but learned "here, you learn fast on your own" with patience and resilience. Rindia described how she enjoyed socializing with Americans, but she looked forward to the collective support of other Muslim women who had similar challenges, strong attachment bonds, and a sense of social responsibility to help others in America, as was the case with Uleban.

Language, Laws, and Regulations in America. The majority of the Muslim/Arab participants showed unhappiness about their lack of communication in the new environment. The findings showed how social class and education affected the participants' decisions for their children's education. Not knowing the language for many of the new-comers imposed limitations and caused them much low self-esteem. Syra did not know English when she came to the United States, so she focused on socializing with other Arab women who spoke her language. She struggled to understand how the educational system worked and what rights she had as a parent. She decided to enroll her children in a private Islamic school:

I sacrificed to keep the language. It was important for them to communicate with my family back in Syria and to communicate with other Arabs here. Also, since the courses at the Islamic school are in Arabic, it was easier for me to teach them and to keep check on their homework. They also needed the social support and the feeling that they belonged. Not knowing English, I could not help them socialize with American friends.

Other participants described their confusion and misunderstanding about education and how, as mothers, they had problems with their children's courses, possible placements, report cards, parental interaction with schools, and their active

108

participation in their children's schools. Sjordan described how living in the U.S. required knowledge Muslim/Arab women did not have before. She listed things that she would have asked Muslim/Arab women who considered immigrating to the U.S. to learn before they come to the new land:

If my sister decides to come to America, it will be very helpful for her to have information about how to find a doctor, how to get insurance, how to get credit card, how to read directions, who to ask for taxes, how to find a good immigration lawyer, and of course English.

Sjordan knew of many Arab women who did not drive and they found themselves restricted to their homes: "Their husbands do not teach them, and the wives cannot be with strangers so that strangers cannot teach them, and their husbands come back from their work late, so they are not interested. Those who do not drive have to wait for their husbands to do everything for the family including shopping for them." Rindia described the stress she felt and the difficulties of her understanding "the road ways. The concept was difficult… the rules and regulations are more difficult to understand and to follow, but need to be taught." Sjordan described how the United States was regarded by her people back in Jordan: "We see Hollywood, and by God, back home, they think that life in the U.S. is easy, the land of wealth and dreams. It is tough work. If you are here to work, then you need to apply for everything; everything is organized, not like our country, and one needs to know all the how to."

Modernity and Traditionalism: East and West. The study's findings concurred with Abu-Lughud's (1998) Postcolonial theory and rethinking of East/West Politics that presented the troubling questions concerning the relationship between modernity, the West, and the role of women in a Muslim society:

> Women have had a prominent place in the debates and struggles over this question …

a struggle between those who seek to locate women's emancipation, …, at the heart of the development of a nation and of society and those who try to dislocate such a project as an alien Western import. (Abu-Lughud, 1998, p. 243)

All the participants came from lands that were colonized or semi-colonized by the West, and they felt that the distinction between modernity and tradition (with its correlated backwardness) was paired with that between the West and the non-West. Europe was modern: the East was not. How might one become modern when one was not, could not be, or did not want to be Western? The study showed how the participants had different views on modernity, traditionalism, and traditions as the participants showed willingness to be modern, but they were against giving up their traditions and their values. The participants were all proud of their Islamic culture and history, and many felt it was their duty to protect the enlightening culture Islam once had; "I am proud to be a Muslim and an Arab" was stated by many participants, reflecting Guenon's (1924) traditionalism philosophy "that the modern world is not the result of progress out of darkness but of descent into darkness … What has been lost — and what needs to be recovered, reinstated even — is 'tradition'" (p. 19). Many Muslim participants did not oppose the West, but they did not wish to live its modern life. They resorted to traditions that helped them stay in harmony with their society, community, and faith. This explained why Aegypt started wearing a head cover after the tragic loss in the Six-Day-War against Israel and why many Muslim/Arab participants started committing to Islam and to hijab after living in the United States, and not before. Modernity, to them, was not what they wore and how they looked, but it was a pride in a traditional Islamic past and a conscientious change in selecting what fitted best to their culture and life, echoing Guenon's Traditionalism that what mattered was not the religion of the future but the

tradition of the past (Sedgwick, 2004). The participants had different definitions of freedom, feminism, and modernity, but all expressed how they valued freedom in America. For some, freedom meant making decisions on their own without consulting their husbands, as were the cases with Mcyprus and Dturk. For others, freedom meant liberation from traditional responsibilities as home and extended families, as was the case with Niran. For some others, it simply meant being able to leave home alone, as were the cases with Syra, Uleban, and Aegypt.

The participants reported different meanings of feminism. Syra and Ziraq did not feel comfortable with the naming to start with, but then Syra agreed that feminism to her, was her right to study and get a job. Aegypt, at a higher level of education, stated that Islamic feminism is a reform movement that was supposed to give rights to women within Islam. Aegypt trusted that women had "roles in society and they should keep them" while demanding new interpretations of the Quran. All insisted that they were treated better in America by their husbands than if they were back in their homelands. Ziraq emphasized how her husband listened to what she said, "not if he were in Iraq, he would not."

Traditional Dress and Veil (head cover). Most of the participants wore conservative dress with a hijab that hide all physical attractions. So, what is behind such a practice? Women's dress in Islamic culture is based on a principle of female modesty. Customs of the time, place, and social class of the woman influence what she might wear. Some options include hijab -- or modest, loose clothing and a scarf over the head and under the chin -- and burqa or burka, a more complete covering of the head, face and body. The participants in the study showed distinct practical advantages for adopting Islamic dress. Aegypt told of the ease she felt in public with the dress that protected her from sexual harassment. Rindia never wore a conservative dress or a hijab before coming to the U.S.; however, she started

studying in the mosque and felt different from all other women: "I was a new bride, and I felt alone when they would ask my husband (in the mosque) to socialize with the men, and I was left alone with the women who all dressed conservatively. At first the hijab, it felt like a social pressure, then I took the decision. I came here in February and it was in August when I make that decision."

The participants who wore hijab voiced that by adopting Islamic dress they were saved the expense of acquiring fashionable clothes and having more than two or three outfits. Some believed that the dress also protected them from male harassment. At the same time it declared women's presence in public space to be in no way a challenge to or a violation of the Islamic sociocultural ethic. Sjordan wore hijab that covered her hair and a pantsuit often with long jackets, very similar to the Westerns clothes but with covering all the body with exception of the face and the hands. To prove her point, Uleban described how a visit to the mosque showed how "the dress of all was, in a strange sense, democratic, as it erased class and origins." In her words, Ziraq said:

> I always wear the hijab. I feel awkward if I do not, something like naked. I wore the hijab from an early age. My mother wore it and never objected. I feel free in wearing it. I do not need make-up or a big budget for clothes. I feel modest and just like all other women in the mosque. Modesty is a requirement and showing physical attractions are distractions that are not needed.

My participant from Jordan reminded me of the many rape incidents that were results of exposed beauty. Suae emphasized that "the cover is [her] identity as a Muslim female" However, both Niran and Mcyprus did not share the same attitude towards wearing a veil or a hijab. Niran believed that the "veil is a prison;"

and Mcyprus stated that "all the rituals are nonsense, I don't do that. It (hijab) looks so fake and unnecessary and is a requirement set by men, not by God." Still, whether the participants veiled or not, they all shared a feeling of being judged especially after the 9/11 tragic event. Syra felt afraid to leave home because she was visible with the hijab, and Sjordan felt that she did not "know how would Americans think of her" after the event.

Misunderstandings and Conflicts of Muslims/Arabs. The findings agreed with Shakir (1997) who acknowledged how the "United States is a country that may offer immigrant women new opportunities for self-direction and achievement, yet often seems dangerously hostile to the Arab world" (p. 10). Such conflicts are rooted in misunderstandings of how the Arab Muslim live and understand life. The participants talked about how many Americans assume that Muslim women are submissive and weak. The Muslim women I interviewed did not feel oppressed or degraded. Narrative stories from participants were proof of their successes, socially and educationally. However, the priorities of the Muslim women I interviewed were different from the priorities of modern working women in the West. Sjordan emphasized that "her priority is her home, her husband and son." Uleban volunteered all her time after prioritizing what she needed to do for her husband first. Syra had the same feelings of taking care of all the details to help her husband first. Such an attitude to Muslim women is not oppressive, but is a major part of their duties as Muslim wives.

The problem with young immigrant women is that they come to a country that attempts to tell them there is a conflict between Islam and the West and that the new world is liberationist and they will become free here if they give up their traditions from the East; this seems to mean that they have to give up what they used to hold to be an appropriate and proper perspective of the world. They have to undergo a cultural assault; they have to flip over, and it is impossible to throw away what somebody used to

be in order to become something else.

So, how do Muslim women reconcile the two? They reconcile the two through long experience, which is informal education, or through short experience, which is formal education. Formal education is short and it is intensive while the informal may be more meaningful to their lives. Reconciling the conflict between Islam and the West is a way to help Muslim immigrants integrate into the current experience. Sjordan emphasized that "we are here, but nothing has changed… We like to teach our children to celebrate Ramadan as other religions celebrate their feasts." Niran stated that she "loved the freedom in America, but … could not change all her life to become like all American women."

Education: The Hope of Immigrants. All the participants placed excessive trust in the ability of the educational system to act as a means of paving the way for the success of their children. They all, regardless of their educational levels, emphasized their faith in encouraging their children to take the opportunities of the availability of education. Afshar (1989) described how immigrants consider education "as the best strategy for success both economically and even in terms of dealing with racism" (261). He affirmed that the Muslim women he interviewed, similar to participants in my study, "were all committed to the education of their children, even where, …, they had to pay high fees that they could ill afford" (p. 261). Syra, although not educated, paid a considerable percentage of the family's income to teach her children in an Islam private school because she wished them to learn Arabic and religion; she also feared that they might be discriminated against in public schools. Syra voiced her "dream is that [her] children will continue their education…that she sacrificed hundreds of dollars a month to keep the language … and for their social acceptance." Mcyprus, not only checked daily on her children's assignments, but she volunteered in their schools in order to keep informed on every aspect and need for

Conclusions & Implications

their education:

> When my children started school, I started participating heavily in my children's classes. When high school came, I scheduled myself to volunteer in their schools. I did the test monitoring of students, field trips, and labs.... I wanted to make my children see me around… it made them feel better and more focused on their education.

Home is not Included in the Curriculum. All the ten participants in the study were in the habit of spending time back in their homelands. Some of them visited every summer, and others had the will but not the ability to afford a trip back every year. It was interesting to find that the Muslim women, from different parts of the world, shared their willingness to spend time with their families back home. Sjordan described how spending summer in Jordan was "the only opportunity for her child to meet his grandparents … to know the language… and to know Islam." Dturk described how when she spent summers in Turkey, she took her children everywhere possible to learn more about their country noting, "there is nothing in the American curriculum that teaches about us." I know from my experience with my sons that they barely recall anything in Lebanon other than some incidents from the war, and although they studied in American schools from the age of five, they did not study much about Lebanon, except that Lebanese food is good. Afshar (1989) affirmed that

> despite the deep commitment of Muslim parents to schooling, in practice the curriculum falls far short of their needs and expectations. Not only is their historical experience totally ignored, what history of imperialism there is, is couched entirely within the imperious perspective of the colonizers. Nor is there much concentration on

the geography, culture, language or religion of immigrant communities. (p. 263).

Not finding much material taught about Arabia and Islam in the American curricula, the Muslim participants needed to fill the gap of teaching their children about their culture and faith. Those who were committed to the mosque, like Syra, Rindia, and Sjordan, chose to educate their children in Muslim schools; others, like Niran, Mcyprus, and Dturk taught their children about Islam and Arabia on their own and by visiting their original homelands every summer to keep the connections.

Cultural Pluralism and American Educators. Muslim communities are growing all over the country and their children are filling American schools. Assuming that America is pluralist and a democracy, it becomes imperative for educators to know more about Islam, Muslim students, and Muslim countries. As we live in a global world, we need to have educational programs for teachers that recognize and respect differences and that promote cultural pluralism. Kymlicka (1996) maintained that "in a liberal democracy, citizenship rights also include the cultural rights of minority groups" (p. 26). In a study on "Muslim Children in Urban America: The New York City Schools Experience," Ahmad and Szpara (2003) affirmed that "in order to participate in American civic life, to educate children in the secular public schools, and to seek better economic opportunities, Muslims must not be treated differently from other groups" (p. 297). The findings of the study showed that "Muslim children feel that most teachers in public schools know little about Islam, …, that misperception and negative stereotypes about Islam and Muslim values are pervasive in schools, …, that Muslim children find no dichotomy between their loyalty to America and their Islamic faith" (pp. 298-300). To teach more effectively, teachers need to understand and appreciate the differences in their students' lives, and they must "respect the cultural and religious identities of all groups and manage their classrooms accordingly" (Ahmad &

Szpara, 2003, p. 399). When Rindia was asked to write an article for the Islamic newsletter in the mosque, she "felt passionately about writing it ... as a means of supporting women in an Islamic feminist way ... and to educate about Islam (not many women in the mosque could write articles)." Uleban volunteered in schools and in correctional centers to educate about Islam and to show that Muslims are interested in giving back to their communities, only when acknowledged and given chances.

Ultimately, I will propose that, in order to prevent the occurrence in the future of similar experiences regarding the education of their children, the laws in a new land, the possibilities and opportunities that are available, and the cultural stress immigrant women have, I believe that there should be programs of integration which will make it easier for Arab/Muslim women to enter and become integral members of American society, if and when they choose them. Such programs should aim at including the new immigrants rather than excluding them because they think or believe differently. Interviewing the women taught me that there was a need to develop such a program of education, which is undergirded by an appropriate curriculum both formal (as regular courses in colleges), or informal (as courses to be taught in mosques, public school classrooms, churches, community centers, or elsewhere). Formal education is usually intense and limited by time and places (schools or colleges), while the informal courses can be open to all who are interested participants. Berry (1998) described that "integration can only be freely chosen and successfully pursued by nondominant groups when the dominant society is open and inclusive into their orientation toward cultural diversity" (p. 45).

Implications: A Curriculum

So, what can be done? What programs can be put in place to minimize the stress future immigrants tend to experience as they attempt to become a part of American society? Why do we need to consider such programs? How does a democratic curriculum

ease the tension and the assimilation of Muslim/Arab women? And how far is society committed to a moral obligation in education? Shulman (1997) stated that "research begins in wonder and curiosity but ends in teaching. The work of the researcher must always lead to a process in which we teach what we have learned to our peers in the education community. Our work is neither meaningful nor consequential until it is understood by others" (p. 6). For the study to be of value that can be translated in education, it invites researchers to prepare a curriculum that can be taught formally or informally, but that can ease the integration of newcomers to the United States. Since the purpose of immigration becomes assimilation, it is important that we seek ways of making acculturation a smoother process for those who are new immigrants for a more unified American society. My study was not only a description of the women's experiences, but it intended to show an important problem and lead to a curriculum in education that can ease the tension of immigrants in a new environment and can help them make better choices with their children's education, their own education, and their lives. From the existing literature we find that it is difficult to expect Muslim/Arab women to adapt or assimilate in a foreign environment, but they can integrate by keeping what they hold dear of their traditional culture, while acquiring new feminist ideas they choose to apply to their lives without much conflict.

What the Curriculum May Look Like. An elaborate curriculum of integration can explore every aspect of Muslim women's lives to live well and be well in the American environment. Although my project does not aim at presenting a specific curriculum, I still believe that a well-tailored curriculum in the American educational system for the women's integration can facilitate the liberation of Muslim women, if they want it. I trust that an appropriate curriculum can follow the example of the theorist Knowles's (1970) The Modern Practice of Adult Education that

relied on four andragogical assumptions for adults:
1. move from dependency to self-directedness;
2. draw upon their reservoir of experience for learning;
3. are ready to learn when they assume new roles; and
4. want to solve problems and apply new knowledge immediately. (p. 4)

Accordingly, Knowles suggested that adult educators should:
- set a cooperative learning climate
- create mechanisms for mutual planning
- arrange for a diagnosis of learner needs and interests
- enable the formulation of learning objectives based on the diagnosed needs and
- interests
- design sequential activities for achieving the objectives
- execute the design by selecting methods, materials, and resources; and
- evaluate the quality of the learning experience while rediagnosing needs for further learning (p. 4)

A curriculum is any program of teaching or learning that includes disciplines of sociology (whom we should teach); philosophy (why we should teach); and politics (when and how to teach and distribute knowledge). A curriculum to teach Muslim women immigrants needs to highlight their problems and enable their voice (as a metaphor for power to control one's life and destiny) to be heard and appreciated. A special curriculum will be introducing to them a higher order of transformation that may lead to feminist liberation or to better integration so that they can become effective parts of the society in a seamless manner without the unnecessary tension. It is important to know that there are special educations for Muslim women offered

by the Nation of Islam that teach tremendous leadership and organizational skills. However, they are indoctrinated to subject themselves to men (fathers, brothers, husbands, etc.). The result is that these women become highly competent leaders but still remain subordinate leaders, under the supreme surveillance of men. What I propose is a curriculum that includes projects that can reconcile between traditionalism and feminism, a curriculum written and taught by women to express their voices.

A Curriculum with Women's Voices & Female Coordinators. When a committee member asked me what made the curriculum I proposed different from what some churches and social services teach immigrants, ranging from learning English to acquiring computer skills, I realized that I needed to be clearer about the issue of voice. What I propose to do next is to work on a curriculum for women, by women, and mainly about women. I have asked two female friends, one from Jordan and another from Palestine, to assist in creating the curriculum. Our plan is to interview more Muslim Arab women, categorize their needs, prepare texts that answer their requirements and that can encourage and enrich their participation in the American society. Learning about other women who made it successfully in a new environment and sharing real life experiences from others, can help us choose the content that is most suitable for our participants. Such a curriculum will be taught in a space that is not dominated by men, not necessarily in mosques where women who join have to be committed Muslims and consequently learn what men advised them to learn. I wish to work on a curriculum without men's participation, guidance, or content. I will seek deeper knowledge from women by "providing structures that allow [them] to speak for themselves … This means that such experiences in their varied cultural forms have to be recovered critically in order to reveal both the strengths and weakness" (Giroux, 1985, p. xxiii).

The curriculum that I intend to set will be one taught by

women where participants share their knowledge without fear and with critical dialogue. All who wish to attend, whether Muslims, Arabs, or any other religions, can enrich the material with their voice. I intend to set a curriculum from a Freirian point of view that is "based on dialogue and debate addressing elements of participants' everyday life and reality. All members will bring their experience, ideas, and prejudices to discussion. Out of this raw material, they collectively seek the most coherent and satisfying analysis and explanations of events, situations, and processes which confuse or concern them" (Lankshear, 1993, p. 112). Why female coordinators? Simply because female coordinators may share similar concerns and challenges, especially if they know the culture. A coordinator's role is to assist "other participants in their efforts to produce a more critical interpretation and understanding of this content within a discussion setting where each person has an equal voice" (Lankshear, 1993, p. 112). The lived experiences of the participants may turn into testimonial literature that can teach new female immigrants how to better cope with the cultural gaps, can help future immigrant Muslim/Arab women ease their tension and assimilation in the U.S., can educate on Arabs/Muslims in a multicultural society, and can introduce resolutions to the female immigrants' concerns. Coincidently, just last semester, I was asked to teach a new course at a college on Arab American experience. I felt, for the first time, that a college of education had included the Arabs in their curriculum as part of the American Studies courses. Researching for the course has and will definitely provide more material for the curriculum that I intend to set as my next project.

Elements of the Curriculum. In planning a curriculum for Muslim women, we need to consider its three elements: content (the lessons), methods (teach and learn), and media (what kind of pedagogy). It will be important to choose a curriculum that deals with critical feminism taught in a manner that Muslim immigrant women learn to develop critical thinking and question what they

hear and say. The special curriculum is intended to educate adult Muslim/Arab women in communal, weekly women's club, or social services. It is not intended to be systematic and formal like the curriculum of K-12 levels, but rather as an adult education that can be informally presented or offered in colleges.

Possible Contents of the Proposed Curriculum. From what the Muslim/Arab participants shared in their interviews, I concluded that there was a need for a curriculum that can teach them English on many levels, the geography and history of America, social and medical services, taxes, job applications and search, educational system, and literature that includes women's lives and voices of feminist Muslim writers on awareness, education, liberation, and veiling. Teaching about the value of diversity and the global world may give the women a sense of worth and belonging to a new open society. Debating on political, social, economic issues can help develop critical thinking, and including liberating and feminist literature from Freire, Shaarawi, Hooks, Gilman, Tuqan, and Ameen can widen the horizon of feminism and human rights.

Since a curriculum is to transmit knowledge, achieve a goal as a products, and is a process that may lead to praxis, any suggestions that can help the objective can be favorable additions to the proposed curriculum. As long as the objective is to present a product (curriculum) that can help immigrant women to organize their lives better in all aspects of participation in social, economic developments, educational systems, and legal aspects, then we can expect a smoother integration for them. So, educating future Muslim/Arab immigrants to ease unnecessary cultural tensions in centers accessible to them can prove to be democratic.

Education is a Moral Obligation: Theorists Emphasize. In a society that is diverse, multicultural, and democratic, there is a need to include all immigrants in the process of integration.

The Muslim/Arab women's experiences, and the problems they face, require an urgent attempt and an educational response so that society can help minimize the trauma in the integration of new immigrants. Culture is a totality of ways a certain people live their lives the way they do, because, that is how they understand the world. While a people's understanding may change over time, especially after living in a new culture for a time, they remain attached to their socialized culture, for very long, if not a life-time. However, the majority of Muslims/Arabs who live in the U.S. are American citizens, and so are all the participants in the study (with the exception of one who came as a student). Including them, and realizing their rights in the community, is a moral obligation. Dewey (1966) stated that "there is more than a verbal tie between the words common, community, and communication … the communication which insures participation in a common understanding is one which secures similar emotional and intellectual dispositions-- like ways of responding to expectations and requirements" (p. 4). It becomes a moral and civic duty for the society to become desirable. Dewey (1966) described how

> an undesirable society … is one which internally and externally sets us barriers to free intercourse and communication of experience. A society which makes provision for participation in its good of all its members on equal terms and which secures flexible forms of associated life is in so far democratic. Such a society must have a type of education which gives individuals a personal interest in social relationships and control, and the habits of mind which secure social changes without introducing disorder. (p. 99)

Recognizing the lived experiences of Muslim/Arab women is a way of acknowledging the need for their smoother transition

in the process of acculturation and integration in a democratic society. Freire's (1991) "Unity in Diversity" described how

> texts that exclude cultural comparisons and conflicts from curricula define acculturation as a one-way process rather than as an interactive one. They implicitly promote a view of learning about a new culture as a mechanical process of superimposing one set of norms on another. This view does not allow for meaningful cultural transformation, the creation of culture through a process of critical and selective integration of the old and the new (p. 155).

What I hope for is that this study may lead to a curriculum that benefits immigrant Muslims/Arabs. Plato's Republic recommended education for its ability to develop skills which benefit society and the power to reform both the individual's as well as society's characters. The recommendation for education has a moral significance. Why we need to prepare a special curriculum for Muslim/Arab immigrant women could be answered by a quote from Michael Apple's Ideology and Curriculum (1990) that provided a look at his professional and personal mission: "I am even more convinced now, that until we take seriously the extent to which education is caught up in the real world of shifting and unequal power relations, we will be living in a world divorced from reality" (p. viii). Examining the cultural, political, and economic contexts of education reflect on Apple's moral convictions: "The theories, policies, and practices involved in education are not technical. They are inherently ethical and political, and they ultimately involve...intensely personal choices about what Raskin called 'the common good'" (Apple, 1990, p. viii). Including knowledge about Muslim/Arabs in the American educational system is an inclusive mission for the common good of a pluralistic society seeking multicultural education.

A Curriculum of Peace. In a multicultural educational curriculum that is needed for American students' global education, Guindi (2003) emphasized that:

> it is time for academe to look seriously into the educational gap in its curriculum. American and Ethnic Studies centers must include Arab and Muslim Americans... students in U.S. educational institutions are entitled to learn about the entire fabric of U.S. ethnic diversity, particularly in the context of current global landscapes which is most relevant today as the United States passes though a major crisis of insecurity. (p. 634)

September 11, 2001, left many Americans wondering who Muslims/Arabs are and overnight "Arabs and Muslims have become the most visible, the most targeted, and the lease understood ethnic group in America" (Guindi, 2003, p. 634)

Still, inter-ethnic and intercultural misapprehension stand at the root of current conflicts in the world, from Iraq to Iran, Palestine to Israel, India to Pakistan, England to Ireland, and elsewhere. There is so much violence in the world and global peace is needed now more than ever; peace between Arabs/Muslims and Americans/Christians is even more urgent. Therefore, the curriculum I propose will include debates about Islam, Christianity, East, West, women in cultures, immigrants from all over the world, literature by women, and varied skills for betterment. Such a curriculum may stand to make a significant contribution to the goal of inter-ethnic, inter-racial, and intercultural understanding, and global peace. Global peace is difficult to attain, but starting with a group of Arab/Muslim women in the United States, who have experienced efforts to bridge the religious and cultural gaps between the two cultures, and who at times, have contradictory views about the West in general, and the United States in particular, can be a start with a

segment of American society, one that has been misunderstood for some time. A reflective curriculum of peace based on Muslim/Arab women's stories is a form, not only of "engaging stories of pain and suffering, but also for constructing a new narrative of hope through the development of a pedagogy capable of [emancipating women]" (McLaren & da Silva, 1993, p. 68). A curriculum that aims at bridging the gap of fear and ignorance between the two cultures can also "free from the mystification that results from living unreflectively in such discourses" (p. 68).

Limitations & Future Research

Although Islam covers more than a billion in the world and is the fastest growing faith in this country, the research literature concerning Muslim Americans has remained inadequate. Definitely, the study could not represent every Muslim immigrant in America or any group of them. The participants were made up of various races, backgrounds, classes, and educational levels, and they were all in one state. I chose not to include Muslim women from outside the state. The project showed reserved Muslim women who believed that men and women should not share the same spaces, and other more contemporary Muslim women who believed in their rights to work and to be effective in their families. However, the limitation of the number of participants could not allow a clear cut distinction between those who were conservative and those who were not. Future researchers, as well as myself, may wish to explore the diversity among the Muslim women participants to understand more deeply their struggles. I believe that this research has laid the foundation for better understanding of Muslim/Arab immigrant women in the United States. A longitudinal study examining how new immigrant Muslim women can integrate easier with a special curriculum prepared for them would be particularly enlightening.

Conclusions & Implications

Final Thoughts

Islam is today very present in the United States and in the Western awareness as a result of immigration, politics, and conflict. Muslims/Arabs have experienced a history of distrust of the western colonizers, have faced failure of secularism, have witnessed the dangers of capitalism, and have defended their culture from the Eurocentric and American perception of them as outdated and irrelevant. I believe that the challenges now are even harder for immigrant Muslims/Arabs who have to find a balance between their history, religion, beliefs, and their new life in the America. Presently, Arab and Muslim people tend toward a view that America is a liberal, open, but permissive society, full of economic opportunities but is shameless in the degree of liberty it accords to women. Some Arab women fear such freedoms; this is why many of them are mindful in keeping their identity to mirror a conservative lifestyle, as they do not easily welcome or encourage change.

When I decided to study Muslim/Arab immigrant women in the United States., I considered how the image of Muslim/Arab women in the West has always been categorized and politicized. Malti-Douglas (1992) argues that, "the image of women languishing under the yoke of Islam titilated the Western observer and permits him to place himself in the superior position. Women and their role become a stick with which the West can beat the East" (p.17). Images of Muslim women from novels of previous centuries, and issues such as harems, rapes, veils, and honor killings highlighted by the media, leave the U.S./West in a position of feeling superior to a culture still widely unknown to them. Focusing on the ills of a culture that spreads over a large part of the world does not "result to form bonds of sisterhood across cultures, nor to depict the happy and unhappy realities of women's lives, nor to liberate Arab women, but rather to establish the superiority of Western women's lives and, through them, Western cultures" (Sabbagh, 1992, p. xiii). I hope that the narratives of the participants have provided

different views of how Muslim/Arab women are in reality.

Continued exploration of the cultural understanding of Muslims is essential to multicultural education that respects diversity in a global world. Cross (2003) stated "for too long, culture has been framed as a problem that must be solved in cross-cultural practice. My message today is that culture is not a problem to solve; it is a resource on which to draw" (p. 355).

When my advisor asked me what I intended to do with the study, I had to find an appropriate answer that related the study to education, my field. So, I concluded that we needed a curriculum of integration. I anticipated that a connection from the women's experiences could be made to the field of education in general. Education is not limited to schooling, and hence the implications may/may not have much to do with classroom teachers, but more with community activists, people who work in mosques or in educational centers-- in other words, educators who work in non-traditional educational settings.

I have seen that many immigrant Muslim/Arab women are breaking away from traditions and are supporting their husbands by seeking education and jobs. All the participants in the study acknowledged major changes in their lives from the time they arrived in the U.S. Many have broken away into the public sphere and all have adapted to new forms of feminism. All the participants acknowledged that now in the U.S., they have new roles in bringing up children and in maintaining their culture. A quote by Hippocrates (1931) that can be applicable to the status of all immigrants "You could not step twice into the same river, for other waters are ever flowing on to you" (p. 254); and here is the greatness of immigration that continuously provides innovation, skills from around the world, and colorful, diverse thinking that makes the U.S. such a unique nation.

References

Abu-Lughod, L. (1998). The marriage of feminism and islamism in Egypt: Selective repudiation as a dynamic of postcolonial cultural politics. In L. Abu-Lughod (Ed.), *Remaking women: Feminism and modernity in the Middle East* (pp. 243- 264) N.J.: Princeton: University Press.

Abuzahra, K.G. (2004). Understanding resilience in Muslim-American immigrant women: An examination of protective processes. Dissertation retrieved October 23, 2005, from ProQuest. (UMI 3119783).

Afari, J. (1998). The war against feminism in the name of the almighty: Making sense of gender and Muslim fundamentalism. New Left Review 224, 89-110. Retrieved November 14, 2005, from http://waf.gn.apc.org/journal7p26.htm.

Afridi, S. (2001). Muslims in America: Identity, diversity, and the challenges of understanding. New York: Carnegie Press.

Afshar, H. (1989). Education: Hopes, expectations and achievements of Muslim women in West Yorkshire. Gender and Education 1, 261-72.

Ahmad, I., & Szpara, M. (2003). Muslim children in urban America: The New York city schools experience. Journal of Muslim Minority Affairs, 23, 295-301.

Ahmed, L. (1992). Women and gender in Islam: Historical roots of a modern debate. New Haven: Yale University Press.

Al-All, N. (1995). Women resisting fundamentalism world-wide.

Women Against Fundamentalism, 7, 26-35.

Alcoff, L., & Potter, E. (1993). Feminist epistemologies. New York: Routledge.

Al-Taimuriya, A. (1965). Women writers and critics in modern Egypt 1888-1963. Unpublished doctoral dissertation, School of Oriental and African Languages, University of London: UK.

Apple, M. (2004). Ideology and Curriculum (3rd ed.). New York: Routledge.

Barakat, H. (1993). The Arab world: Society, culture and state. Berkeley: University of California Press.

Best, S. (1989). Jameson, totality and the poststructuralist critique. In D. Kellner (Ed.) Postmodernism/Jameson/Critique. (pp. 233-368). Washington: Maisonneuve Press.

Belenky, M. F., et al. (1986). Women's ways of knowing: The development of self, voice, and mind. New York: Basic Books.

Berry, J. W. (1998). Acculturation and health. In S. S. Kazarian and D.R. Evans (Eds.), Cultural clinical psychology: Theory, research, and practices (pp. 39-57). New York: Oxford University Press.

Blumer, H. (1969). Symbolic Interactionism: Perspective method. Englewood Cliffs, N.J.: Prentice Hall.

Boekestijin, C. (1988). Intercultural migration and the development of personal identity: The dilemma between identity maintenance and cultural adaptation. International Journal of Intercultural Relations 12, 83-105.

Bruner, J. (1990). Acts of meaning. Cambridge, MA: Harvard University Press.

Creswell, J.W. (1994). Research design: Qualitative and quantitative approaches. Thousand Oaks, CA: Sage.

Collins, P. H. (1998). Fighting words: Black women and the search for justice. Minneapolis: University Press.

Cross, T.L. (2003). Culture as a resource for mental health. Cultural Diversity and Ethnic Minority Psychology, 9(4), 345-359.

Crotty, M. (1998). The foundation of social research: Meaning and

References

perspective in the research process. Thousand Oaks, CA: Sage.

Curran, S.R., & Saguy, A. (2001). Migration and cultural change: A role for gender and social networks. Journal of International Women's Studies 2 (3), 54-77.

De Bouvoir, S. (1953). The second sex. London: Jonathan Cape.

Denzin, N., & Lincoln, Y. (Eds). (1994). Handbook of qualitative research. Thousand Oaks, CA : Sage Publications.

Dewey, J. (1966). Democracy and education: An introduction to the philosophy of education. New York: Collier-Macmillan.

Digh, P. (2003, October). The White Leg Syndrome. Executive Update, 117 (69). Retrieved December 12, 2005, from http://www.asaecenter.org/PublicationsResources/EUArticle.cfm.

Dilthey, W. (1985). Poetry and experience: Selected works, Vol. V, N.J. Princeton University Press.

El-Ghawhary, K. (1994). An interview with Heba Ra'uf Ezzat. In Middle East Report, 26-27.

Faruqi, L. (1985). Islamic traditions and the feminist movement: confrontation or cooperation? [Electronic version]. Muslim Association of Hawaii 5, (4-5). Retrieved March 27, 2005, from http://www.islam101.com/women/feminism.html.

Freire, P. (1981). Education as the practice of freedom. In P. Freire (Ed.) Education for critical consciousness, (pp. 1-61). New York: Continuum.

Gauger, J. (2002). Immigrant Muslim women working in America. Asian Women Workers Newsletter 17(2). Retrieved March 30, 2005, from http://www.stolaf.info/depts/womens-studies.htm

Gay, L.A. (1996). Educational research: Competencies for analysis and application. Upper Saddle River, N.J.: Prentice Hall.

Giorgio-Poole, M. (2002). The religious lives and ritual practices of Arab Muslim women in the United States. Dissertation retrieved October 23, 2005, from ProQuest. (UMI 3054280).

Giroux, H.A.(1985). Introduction. In P. Freire, The politics of education (pp. xi-xxv). South Hadley, Massachusetts: Begin & Garvey.

Glazer, B., & Strauss, A. (1967). The discovery of grounded theory:

Strategies for qualitative research. Aldine, N.Y: de Guyter.

Glynn, D. (2004). Scholars cook up a new melting pot. Chronicle of Higher Education, 50 (23), A10.

Grieco, E., & Boyd, M. (1998). Women and migration: Incorporating gender into international migration theory. Retrieved April 26, 2005, from http://www.fsc.edu/popctr/papers/floridastate/19998.html. Center for the Study of Population, Florida State University, (pp. 98-139).

Guba, E.G., & Lincoln, Y. S. (1985). Naturalistic inquiry. Beverly Hills, CA: Sage.

Guba, E. G, & Lincoln, Y. S. (1989). Fourth generation evaluation. Newbury Park, CA: Sage.

Guenon, R. (1924). Orient et occident [East and West]. Paris: Payot.

Guindi, F. (2003). Arab and Muslim America: Emergent scholarship, new visibility, conspicuous gap in academe. American Anthropologist, 105, 631-634.

Haddad, Y. (2002). Inventing and re-inventing the Arab American identity. In K. Benson & P. Kayal (Eds.), A community of many worlds: Arab-Americans in New York. (pp. 109-123). New York: Syracuse University Press.

Haddad, Y., & Lummis, A. (1987). Islamic Values in the United States. Oxford: Oxford University Press.

Hamlyn, D.W. (1995). "Epistemology, history of." In T. Honderich (Ed.), The Oxford Companion to Philosophy (pp. 242-5). Oxford: University Press.

Harding, S. (1991). Whose science? Whose knowledge? Thinking from women's lives. New York: Cornell University.

Harik, R. & Marston, E. (1996). Women in the Middle East: Tradition and change. New York: Franklin Watts.

Hermansen, M.K. (1991). Two way acculturation: Muslim women in America between individual choice (liminality) and community affiliation (communitas). In Y.Y. Haddad (Ed.), The Muslims of America (pp. 188-201). New York: Oxford University Press.

Hijab, N. (1991). Women and work in the Arab world. In S. Sabbagh (Ed.), Arab women between defiance and restraint (pp. 41-52).

New York: Olive Branch Press.

Hippocrates, J. (1931). Heracleitus, On the Universe. (W. Jones, Trans.). Harvard: University Press. (Original work published in 1931).

Jencks, C. (1987). What is post-modernism? (2nd ed.). New York: St. Martin's Press.

Kamarck, E. (2002, February 11). Afghan women need Islamic paths. Newsday, p.5.

Kay, J. (2004). Making citizens. Commentary, 117(2), 67-70.

Killian, C. (2002). Cultural choices and identity negotiation of Muslim Mughrebin women in France. Dissertation retrieved October 23, 2005, from ProQuest. (UMI 3032635).

Kim, Y. (2001). Becoming Intercultural: An Integrative Theory of Communication and Cross-Cultural Adaptation. Thousand Oaks, CA: Sage Publications.

Knowles, M. S. (1970, 1980) The modern practice of adult education: Andragogy versus pedagogy. Englewood Cliffs: Prentice Hall/Cambridge.

Kramsch, C. (2002). In search of the intercultural. Journal of Sociolinguistics 6 (2), 275-285.

Lankshear, C., (1993). Functional literacy from a Freirean point of view. In P. McLaren & P. Leonard (Eds.), Paulo Freire: A critical encounter (pp. 90-118). New York: Routledge.

Lazreg, M. (1988). Feminism and difference: The perils of writing as a woman on women in Algeria. Feminist Issues, 14(1), 81-107.

Lincoln, Y. S. (1995). Emerging criteria for quality in qualitative and interpretive research. Paper presented at the Annual Meeting, American Educational Research Association, San Francisco, April 18-22.

MacLeod, A. (1992). Hegemonic relations and gender resistance: The new veiling as accommodating protest in Cairo. Signs, 17(3), 546.

Mairson, A. (2005, February). Muslims in America. National Geographic, 207, 2-3.

Majid, A. (2000). Unveiling traditions: Postcolonial Islam in a

polycentric world, NC: Duke University Press.

Malti-Douglas, F.(1992). Women's body, women's world: Gender and discourse in Arabo-Islamic writing. Princeton, NJ: Princeton University Press.

McLaren, P., & da Silva, T. (1993). Decentering pedagogy: Critical literacy, resistance and politics of memory. In P. MaLaren & P. Leonard (Eds.), Paulo Freire: A critical encounter (pp. 47-85). New York: Routledge.

Mernissi, F. (1987). Beyond the veil: Male-female dynamics in modern Moslem society. Bloomington, IN: Indiana University Press.

Mertens, D. (1998). Research methods in education and psychology. London: Sage Publications.

Minces, J. (1980). The house of obedience: Women in Arab society. London: Zed Press.

Moghadam, V. (2004). Towards gender equality in the Arab/Middle East region: Islam, culture, and feminist activism. Human Development Report. Retrieved August 20, 2005, from http://www.feminismeislamic.org/eng/partipants01.htm

Mojab, S. (2001, November 19). The politics of theorizing "Islamic feminism": Implications for international feminist movements. Women Living Under Muslim Laws (WLUML), 23, 15-22.

Nyang, S. S. (1991). Convergence and divergence in an emergent community: A study of challenges facing U.S. Muslims. In Y.Y. Haddad (Ed.), The Muslims of America (pp. 236-249). New York: Oxford University Press.

Ortega y Gasset, J. (1958). Man and crisis. New York: Norton.

Parillo, V. (1966). Strangers to these shores: Race and ethnic relations in the United States. Boston: Houghton Mifflin.

Phinney, J., Horenczyk, G., Liebkind, K., & Vedder, P. (2001). Ethnic identity, immigration, and well-being: An interactional perspective. Journal of Social Issues, 57, 493-510.

Pinar, W. F., Reynolds, W. M., Slattery, P., & Taubman, P.M. (2000). Understanding curriculum: An introduction to the study of historical and contemporary curriculum discourses. New York:

Peter Lang.

Plato. (1983). Republic. (G.M.A.Grube, Trans.). Indianapolis, Indiana: Huckett Publishing Company. (Original work published in 1438).

Prieto,Y. (1992). Cuban women workers in New Jersey: Gender relations and change. In D. Gabbacia (Ed.), Seeking common ground: Multidisciplinary studies of immigrant women in the United States (pp. 25-68). Westport, Connecticut: Greenwood Press.

Read, J., & Bartkowski, J. (2000). To veil or not to veil: A case study of identity negotiation among Muslim women in Austin, Texas. Gender and Society, 14 (3), 395-413.

Rhinesmith, S. (1985). Bringing home the world: A management guide for community leaders of international programs. New York: Walsh & Co.

Rich, A. (1990). When we dead awaken: Writing as re-vision. In D. Bartholomae & A.

Petrosky (Eds.), Ways of Reading: An anthology for writer (pp. 480-498). Boston: St. Martin's.

Rida, A., & Milton, M. (2001). The non-joiners: Why migrant Muslim women aren't accessing English language classes. Prospect: The Journal of the Adult Migrant Education Program, 16, 35- 48.

Sabbagh, S. (1996). Introduction. Arab women between defiance and restraint (xi- xxvii). New York: Olive Branch Press.

Schwandt, R. A. (2001). Dictionary of qualitative inquiry (2nd ed.). Thousand Oaks, CA: Sage.

Sedgwick, M. (2004). Against the modern world: Traditionalism and the secret intellectual history of the twentieth century. Oxford: University Press.

Shaarawi, H. (1987). Harem years: The memoirs of an Egyptian feminist (1879-1924). (M. Badran, Trans.). London: Virago Press. (Original work published in 1945).

Shakir, E. (1997). Bint Arab: Arab and Arab American women in the United States. Westport, CT: Praeger.

Sherman, R., & Webb, R. (Eds.). (1988). Qualitative research in education. Focus and methods. London: The Falmer Press.

Shulman, L. S. (1997). Disciplines of inquiry in education: A new overview. In R.M. Jaeger (Ed.), Contemporary methods for research in education (pp. 3-69). Washington, DC: American Educational Research Association.

Stanely, L., & Wise, S. (1983). Breaking out: Feminist consciousness and feminist research. London: Routlege & Kegan Paul.

Suleiman, M.W. (Ed.). (1999). Arabs in America: Building a new future. Philadelphia:Temple Press.

Thompson, W., & Hickey, J. (2005). Society in focus. NY: Pearson.

Tohidi, N. (2001). Islamic feminism: Perils and promises. Middle East Women's Studies Review, 16 (3-4), 13-15, 27.

Tucker, J. (1993). Arab women: Old boundaries, new frontiers. Bloomington: Indiana University Press.

van Manen, M. (1990). Researching lived experiences: Human science for an action sensitive pedagogy. Albany, NY: State University of New York Press.

Villenas, S. (1996). The colonizer/colonized Chicano ethnographer: Identity, marginalization, and co-optation in the field. Harvard Educational Review, 66, 711- 730.

Williams, R. (1988). Religions of immigrants from India and Pakistan: New threats in the American tapestry. New York: Cambridge UP.

Yin, R. K. (1994). Case study research design methods (2nd ed.). Thousand Oaks, CA: Sage.

Zaharna, R. (1989). Self-shock: The double-binding challenge of identity. International Journal of Intercultural Relations, 13, 501-525.

Index

adaptation 23, 24, 26, 29, 54, 63, 81-83, 87, 130
alien 8, 30, 76, 89, 110
America 5, 7-9, 11, 17, 20, 23, 28, 29, 39, 61, 63, 66, 68-71, 76, 79, 89, 91, 103, 107-109, 111, 114, 116, 122, 125-127, 129, 131-134, 136
American women 61, 71, 80, 93, 114, 135
Arab 5, 7-11, 13-20, 23-26, 28-35, 38-46, 48-52, 54-57, 59-64, 66, 70-72, 78, 80, 84-86, 88-90, 92-94, 96, 98-101, 103-106, 108-110, 113, 117, 118-128, 130-132, 134-136
civil rights 13
class 21, 28, 29, 33, 36-38, 47, 49, 54, 63, 69, 80-83, 92, 94, 95, 108, 111, 112
community 7-9, 11, 18, 26, 27, 29, 30, 34, 37, 47, 49, 64, 73-75, 77, 79, 82, 84, 87, 88, 89, 95, 96, 105, 108, 110, 116-118, 123, 128, 132, 134, 135
conflict 12-17, 26, 31, 39, 42, 44, 45, 56, 61, 62, 113, 114, 118, 124, 125, 127
conscientizacao 10

demographic 8, 19
dialogue 10, 121
diversity 18, 45, 73, 105, 117, 122, 125, 126, 128, 129
education 9, 11, 13, 14, 17-19, 21, 23, 24, 28, 32, 34, 41, 49, 51, 54, 55, 59, 65, 66, 67, 68, 71, 78, 81, 82, 94, 95, 105, 108, 111, 114, 115, 117, 118, 121, 122, 123, 124, 125, 128, 131, 133, 134, 136
Eids 79
environment
 new 8, 9, 10, 17, 21, 26, 28, 36, 44, 52, 61, 64, 78, 81, 82, 83, 87, 106, 108, 118, 120
 traditional 12
epistemology 14, 15, 16, 34, 39, 40, 41, 43, 45, 46
ethnic 25, 26, 28, 29, 34, 70, 106, 125, 134
feminism 9, 12, 13, 14, 16, 19, 21, 23, 29, 30, 32, 33, 34, 35, 39, 40, 41, 44, 45, 52, 53, 54, 61, 73, 78, 80, 98, 99, 100, 111, 120, 121, 122, 127, 128, 129, 131, 134, 136
 feminism in Islam 13, 21, 23, 30, 32, 33, 73
feminist 10, 12, 16, 17, 20, 23,

30, 31, 32, 33, 34, 35,
39, 40, 41, 42, 43, 45,
46, 62, 80, 81, 94, 99,
100, 104, 117, 118, 119,
122, 131, 134, 135, 136
freedom 7, 29, 30, 35, 46, 68,
75, 78, 81, 82, 84, 93,
98, 111, 114, 127, 131
 religious 29
Freire, Paulo 9, 10, 41, 46, 122,
124, 131, 133, 134
gender 9, 12, 14, 16, 24, 27, 29,
30, 32, 33, 37, 38, 39,
40, 41, 47, 51, 80, 81,
82, 95, 104, 129, 131,
132, 133, 134
hegemony 38
hijab 14, 23, 35, 36, 37, 72, 73,
74, 75, 76, 77, 79, 84,
86, 87, 90, 91, 92, 93,
107, 110, 111, 112, 113
identify 52, 59, 60, 80, 90
identity 7, 9, 20, 25, 26, 27,
28, 31, 34, 35, 36, 37,
38, 49, 60, 73, 87, 88,
89, 90, 91, 92, 106, 112,
127, 130, 132, 133, 134,
135, 136
immigrant 7, 8, 9, 14, 15, 18,
19, 20, 23, 24, 25, 26,
27, 28, 29, 30, 40, 42,
44, 45, 46, 47, 48, 49,
52, 54, 55, 56, 61, 64,
71, 82, 83, 86, 87, 88,
90, 98, 103, 104, 106,
113, 114, 116, 117, 118,
119, 120, 121, 122, 123,
124, 125, 126, 127, 128,
129, 135, 136

interviews 12, 17, 22, 37, 44,
45, 47, 49, 50, 51, 52,
53, 54, 55, 56, 57, 60,
62, 63, 76, 79, 80, 103,
122
Islam 5, 7, 8, 10, 13, 14, 15, 19,
21, 23, 30, 32, 33, 34,
35, 37, 38, 39, 47, 50,
52, 62, 72, 73, 74, 75,
76, 77, 78, 79, 80, 84,
85, 86, 87, 93, 94, 95,
96, 97, 98, 99, 100, 105,
110, 111, 113, 114, 115,
116, 117, 120, 125, 126,
127, 129, 133, 134
 Islamic traditions 35, 77, 79,
98, 99, 131
isolate 7
 isolation 87
justice 10, 20, 32, 85, 130
mainstream 7, 13, 33, 92
meaning 10, 11, 12, 15, 17, 19,
29, 33, 47, 53, 54, 55,
61, 73, 80, 88, 130
misconceptions 10
misunderstanding 10, 108
modernism 16, 38, 39, 53, 98,
133
mosque 7, 11, 18, 19, 20, 26,
29, 50, 63, 64, 68, 70,
71, 72, 73, 74, 76, 77,
79, 82, 83, 85, 86, 87,
88, 89, 95, 97, 100, 107,
112, 116, 117, 120, 128
Muslim 5, 7, 8, 9, 10, 11, 12,
13, 14, 15, 16, 17, 18,
19, 20, 21, 23, 24, 25,
26, 27, 28, 29, 30, 31,
32, 33, 34, 35, 36, 37,

Index

38, 39, 40, 41, 42, 43, 44, 45, 46, 47, 48, 49, 50, 51, 52, 54, 55, 56, 57, 59, 60, 61, 62, 63, 64, 65, 66, 68, 69, 70, 72, 73, 74, 75, 76, 77, 78, 79, 80, 82, 83, 84, 86, 87, 88, 89, 90, 91, 92, 93, 94, 95, 97, 98, 99, 100, 101, 103, 104, 105, 106, 107, 108, 109, 110, 112, 113, 114, 115, 116, 117, 118, 119, 120, 121, 122, 123, 124, 125, 126, 127, 128, 129, 131, 132, 133, 134, 135, 138, 139

Muslim Americans 8, 125, 126

narrative 46, 62, 126, 127

objective 7, 15, 20, 30, 31, 40, 46, 47, 48, 59, 63, 74, 83, 88, 94, 100, 103, 119, 122

obligation 7, 57, 80, 118, 123

opportunity 7, 12, 25, 48, 50, 61, 62, 67, 68, 70, 79, 80, 86, 98, 106, 107, 113, 114, 115, 116, 117, 127

oppression 10, 12, 13, 36, 41, 42, 46, 90, 113

participants
 Aegypt (Egypt) 72, 73, 82, 84, 90, 92, 95, 97, 99, 100, 106, 110, 111
 challenges 61, 62, 70
 Dturk (Turkey) 67, 68, 82, 84, 88, 90, 93, 97, 98, 100, 106, 111, 115, 116

fears 71, 84

Mcyprus (Cyprus) 77, 78, 81, 82, 88, 90, 93, 94, 97, 98, 107, 111, 112, 113, 114, 116

Niran (Iran) 75, 76, 81, 82, 83, 85, 88, 89, 90, 93, 94, 97, 98, 100, 107, 111, 112, 114, 116

Rindia (India) 51, 76, 77, 82, 87, 90, 91, 92, 95, 97, 107, 108, 109, 111, 116, 117

Sjordan (Jordan) 51, 79, 80, 82, 84, 85, 86, 87, 90, 92, 93, 94, 104, 107, 109, 112, 113, 114, 115, 116

Suae 49, 50, 51, 64, 65, 81, 86, 90, 91, 96, 99, 100, 104, 112

Syria 17, 21, 49, 56, 62, 63, 65, 66, 67, 69, 74, 81, 91, 97, 106, 108

Uleban (Lebanon) 49, 50, 51, 73, 74, 75, 81, 82, 86, 87, 90, 92, 95, 97, 99, 100, 108, 111, 112, 113, 117

Ziraq (Iraq) 51, 59, 69, 70, 71, 72, 81, 82, 85, 90, 91, 105, 106, 111, 112

Ramadan 74, 75, 88, 100, 114

reality 7, 8, 9, 10, 15, 16, 18, 37, 41, 43, 44, 45, 46, 48, 61, 121, 124, 127, 128

reflections 17

religion 7, 9, 14, 28, 30, 31, 32, 33, 34, 35, 49, 51, 62, 65, 66, 72, 73, 74, 75, 76, 80, 84, 85, 86, 87, 88, 92, 93, 99, 110, 114, 116, 121, 127
religious movements 8
resistance 35, 36, 38, 39, 108, 133, 134
rights, women's 7, 34, 63, 94
social justice 10, 20
spiritual growth 85, 107
spiritual support 85
stories 10, 15, 17, 51, 52, 62, 64, 91, 104, 108, 113, 126
structures 10, 23, 31, 39, 42, 52, 54, 103, 120
struggles 10, 11, 18, 31, 40, 42, 66, 109, 126
symbol 10, 26, 35, 36, 37, 38, 90, 91
tradition 8, 9, 10, 11, 12, 13, 14, 20, 23, 28, 29, 32, 35, 39, 40, 61, 65, 66, 77, 79, 80, 83, 84, 85, 86, 90, 92, 94, 98, 99, 100, 110, 111, 113, 128, 131, 133
traditionalism 13, 14, 16, 39, 44, 45, 52, 61, 110, 120
understanding 10, 11, 13, 16, 17, 18, 20, 26, 28, 29, 31, 39, 40, 42, 44, 45, 46, 47, 48, 53, 55, 57, 83, 100, 104, 109, 121, 123, 125, 126, 128, 129
United States 7, 8, 9, 11, 13, 14, 15, 16, 17, 18, 19, 20, 21, 23, 25, 28, 30, 39, 40, 42, 44, 48, 49, 52, 61, 64, 69, 77, 78, 79, 80, 86, 87, 98, 99, 100, 101, 104, 105, 108, 109, 110, 113, 118, 125, 126, 127, 131, 132, 134, 135
veil 5, 10, 14, 35, 36, 37, 38, 51, 53, 66, 68, 72, 73, 76, 78, 79, 80, 90, 91, 92, 93, 104, 111, 112, 127, 134, 135
visible 14, 25, 33, 36, 113, 125
women's visibility 39
voice
 alternative 33, 34, 35, 99, 100
 dominant 33, 34, 35, 98, 100
 women's 9, 10, 20, 50
West 10, 13, 30, 31, 32, 35, 38, 46, 74, 83, 92, 109, 110, 113, 114, 125, 127, 129, 132
Western 8, 16, 30, 31, 32, 34, 35, 38, 68, 91, 93, 97, 98, 99, 100, 110, 127